D1378951

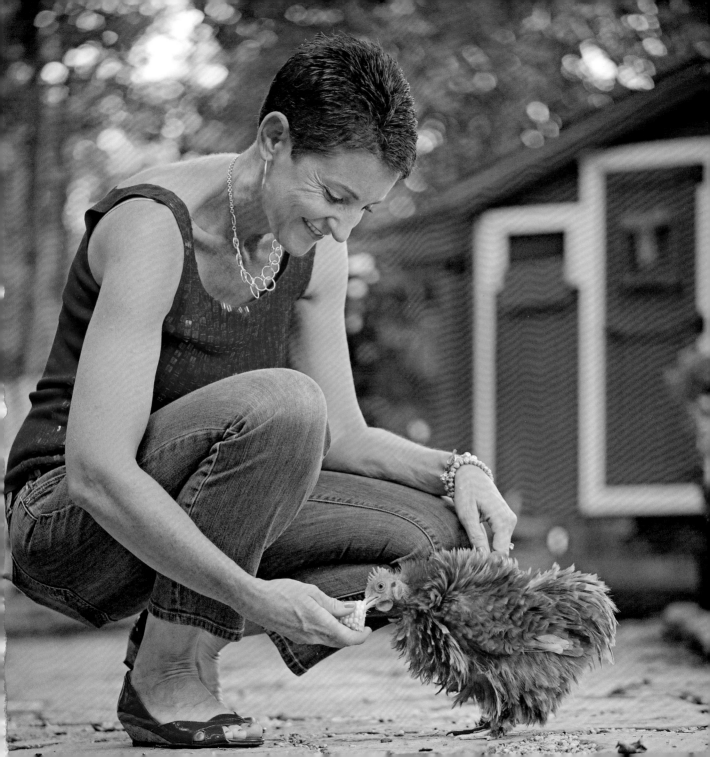

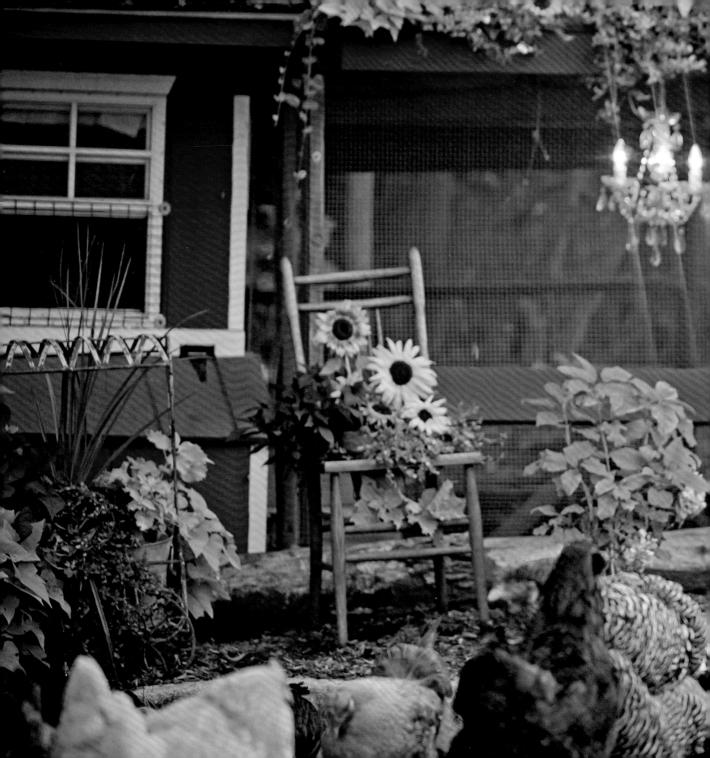

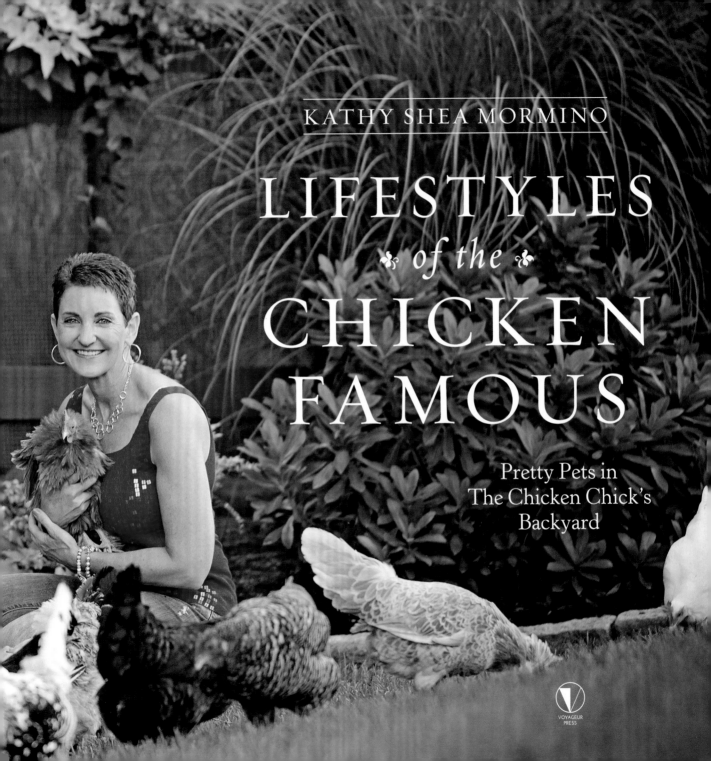

KATHY SHEA MORMINO

LIFESTYLES
✣ of the ✣
CHICKEN
FAMOUS

Pretty Pets in
The Chicken Chick's
Backyard

VOYAGEUR
PRESS

Inspiring | Educating | Creating | Entertaining

Brimming with creative inspiration, how-to projects, and useful information to enrich your everyday life, Quarto Knows is a favorite destination for those pursuing their interests and passions. Visit our site and dig deeper with our books into your area of interest: Quarto Creates, Quarto Cooks, Quarto Homes, Quarto Lives, Quarto Drives, Quarto Explores, Quarto Gifts, or Quarto Kids.

First published in 2018 by Voyageur Press, an imprint of The Quarto Group, 401 Second Avenue North, Suite 310, Minneapolis, MN 55401 USA. T (612) 344-8100 F (612) 344-8692

www.QuartoKnows.com

Voyageur Press titles are also available at discount for retail, wholesale, promotional, and bulk purchase. For details, contact the Special Sales Manager by email at specialsales@quarto.com or by mail at The Quarto Group, Attn: Special Sales Manager, 401 Second Avenue North, Suite 310, Minneapolis, MN 55401 USA.

10 9 8 7 6 5 4 3 2 1

ISBN: 978-0-7603-5933-4

Library of Congress Control Number: 2018936785

Layout: Noelle Davis

Printed in China

CONTENTS

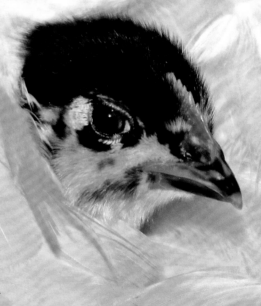

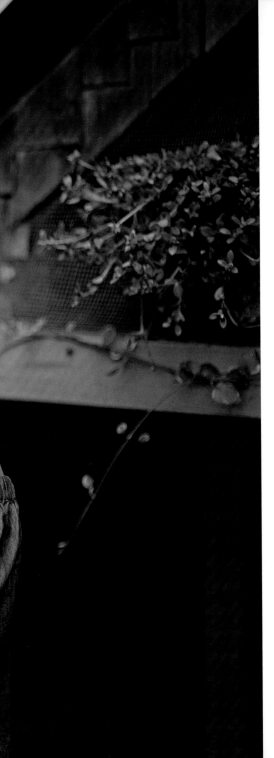

INTRODUCTION

Each of my feathered pets earned its name by distinguishing itself in some way, whether by breed, color, attitude, or behavior. Lucy and Ethel were funny together, Freida was afraid of the other chicks, and Rachel was friends with Monica and Phoebe. I had no way of knowing that some of them would become household names around the world one day.

In sharing the early experiences of my unusual pets on Facebook, I quickly realized the images, filtered through my narrative lens, struck a chord with a diverse audience who flocked to my page for more. Nearly a decade later, many continue to relate my experiences to similar experiences with their own chickens: perhaps a familiar breed, a mutual challenge, or a shared observation. Many reflect fondly on a rekindled childhood memory from time spent on a grandparent's farm, while others express surprise to learn that so many extraordinary breeds and color varieties exist—with individual personalities, at that!

Millions around the world share the joy of my chickens with me. I dedicate this book to them in appreciation for accompanying me on my ongoing adventures with these unconventional pets.

OPPOSITE: Ursula, White Bantam, Frizzled Cochin.

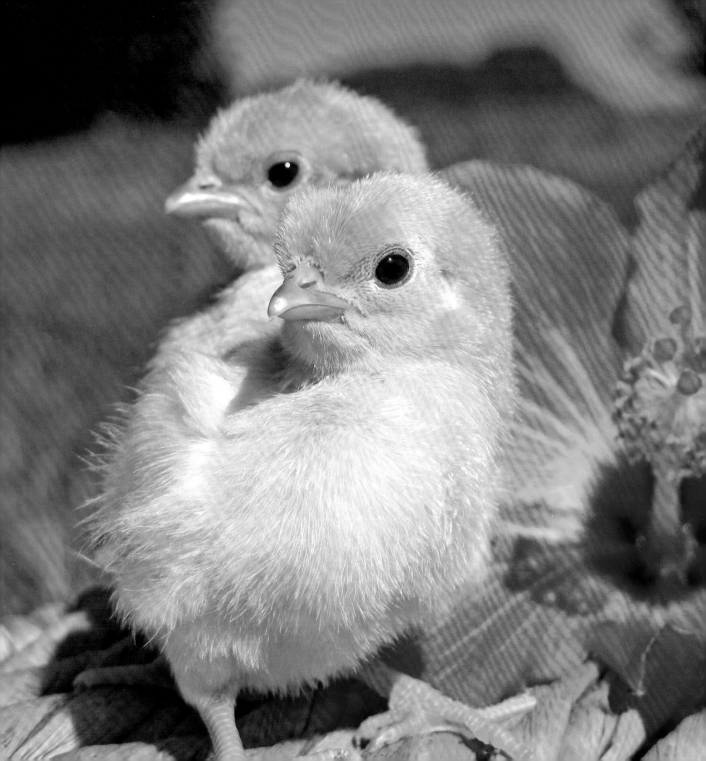

CHAPTER I

The Littles

I have spent countless hours on the ground at chick-eye-level, observing, photographing, filming, interacting with, and cleaning up after baby chicks. Yet I am always astonished at how quickly they begin distinguishing themselves from one another. Their early quirks and behaviors tend to be reliable indicators of their adult personalities. From sweet to sassy, shy to bold, it's always a joy to watch them blossom.

True confession: As a chicken collector (read: hoarder) with more photos of my chickens than my daughters, sometimes I can't remember who's who in baby pictures! Opposite: Serama chicks Caesar (front) and hatchmate.

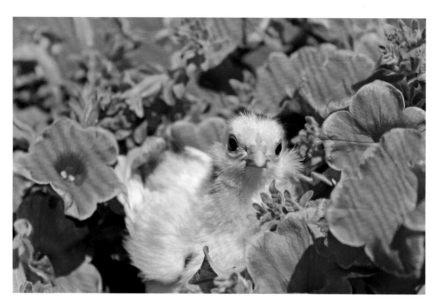

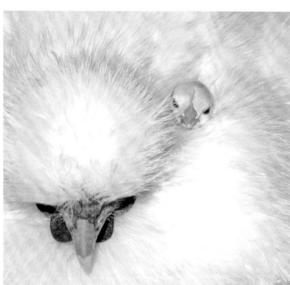

This little fluffernutter on the right grew up to be Ted E. Graham, my Silkie rooster. It's difficult to believe he rose to the top of the pecking order in my flock, but it's true!

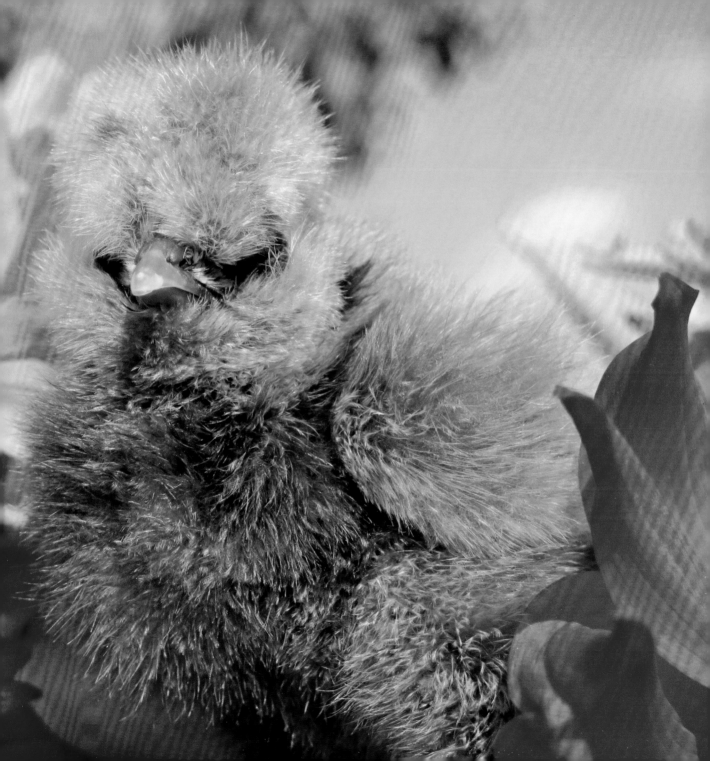

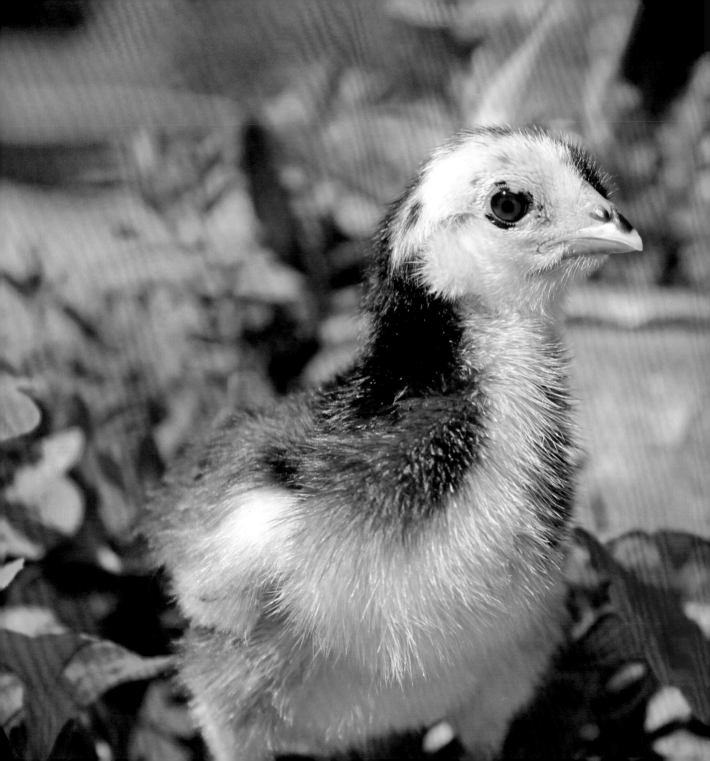

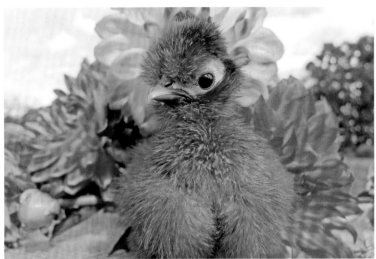

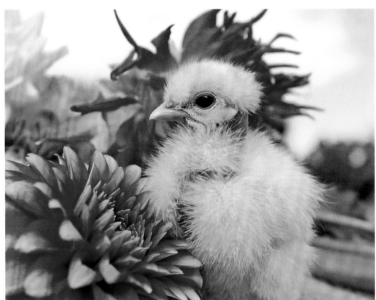

Baby chicks make fabulous models, don't you think? Every side is their good side!

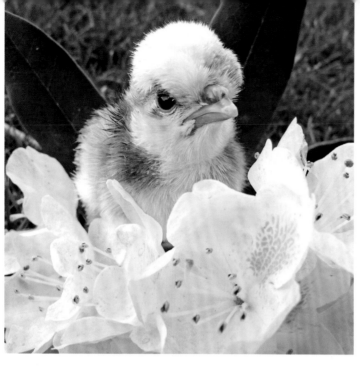

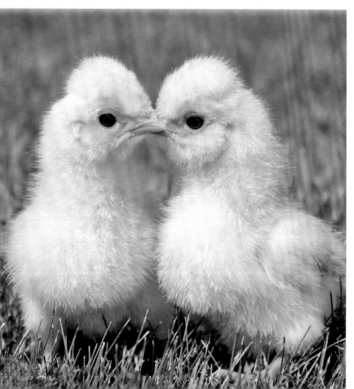

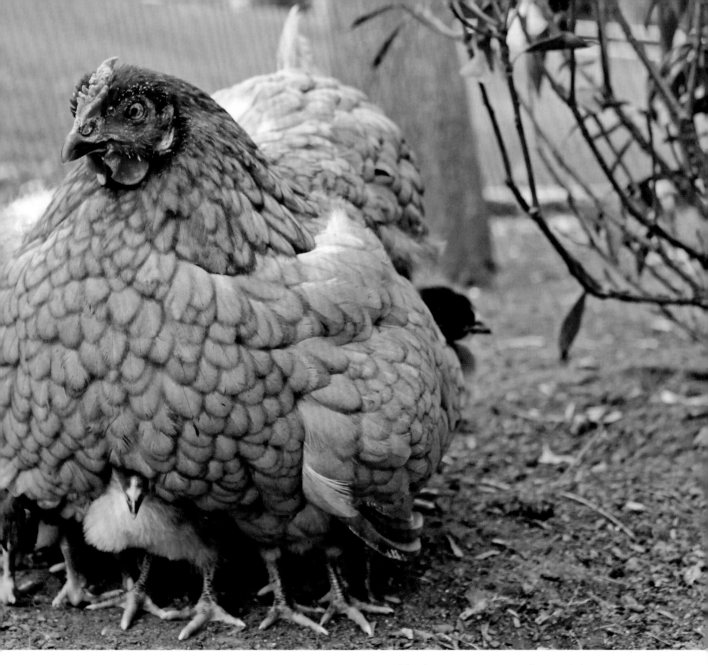

Iris (above) gives new meaning to the term "helicopter mom."

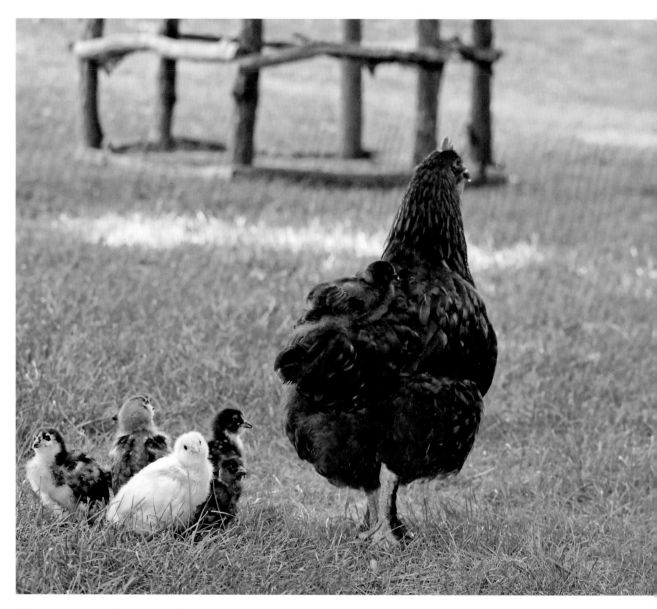

"If any of you kids need to use the little chicks' room, now is the time, because once we get on the road, I'm not stopping!"

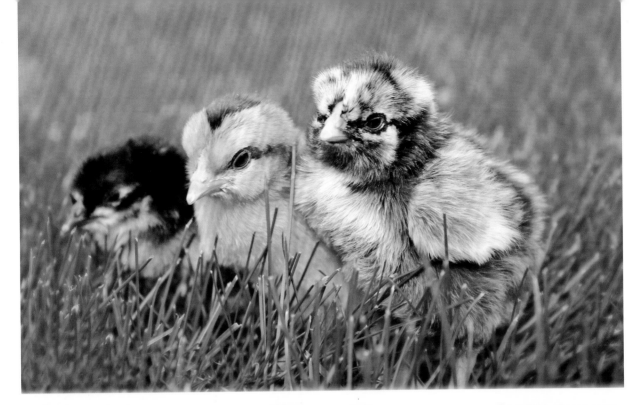

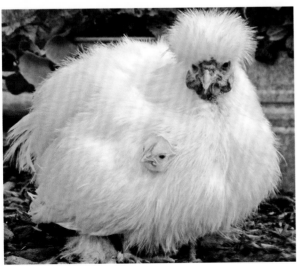

Pure innocence surrounded by simple beauty.

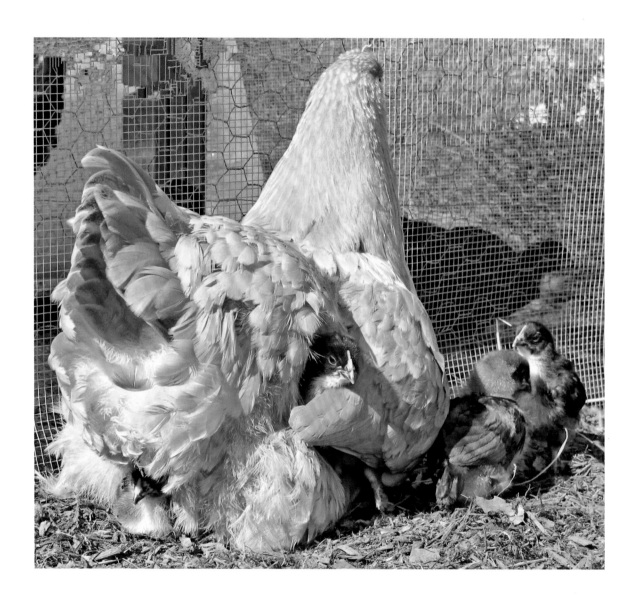

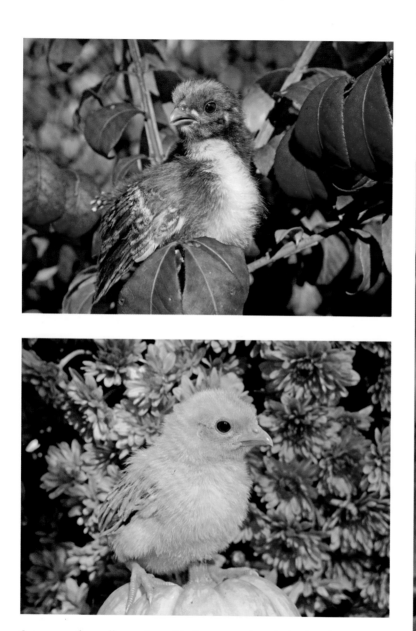

Seramas are the smallest, and arguably the most precious, chicken breed in the world.

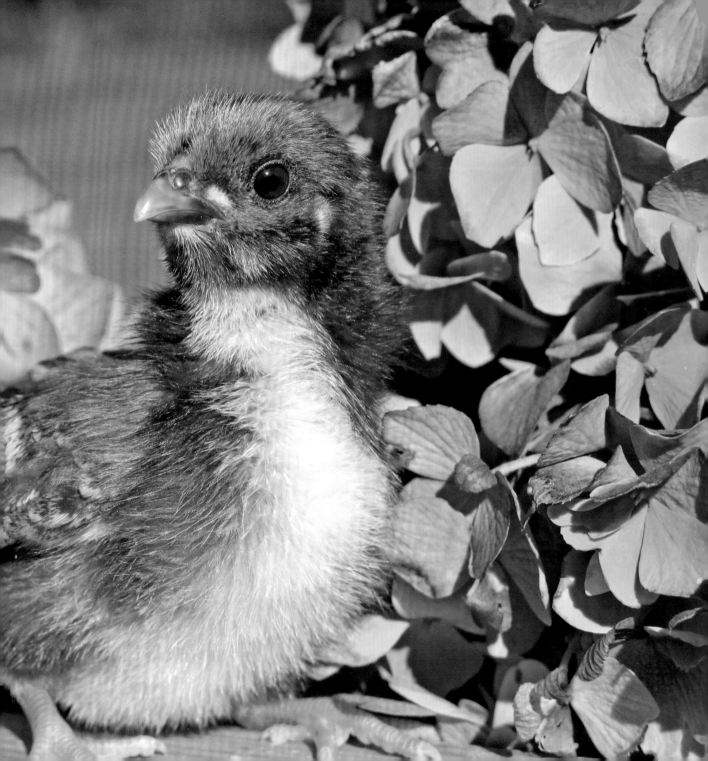

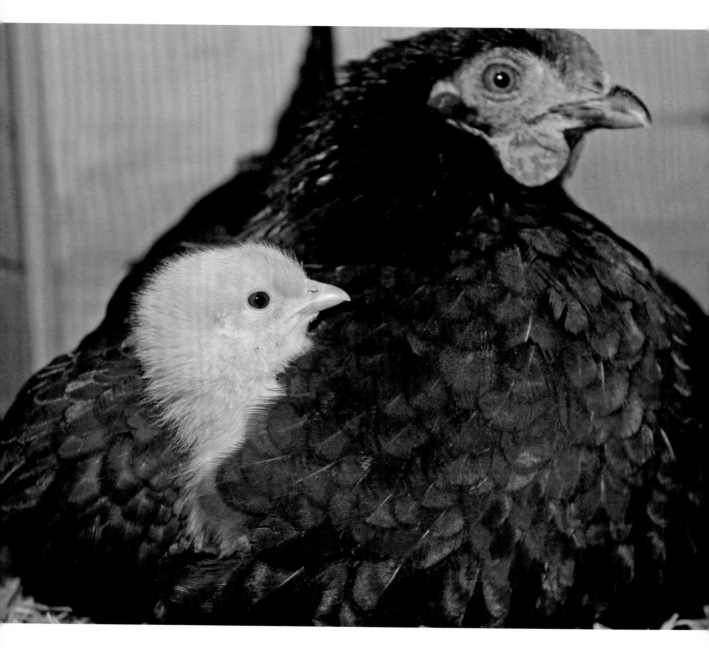

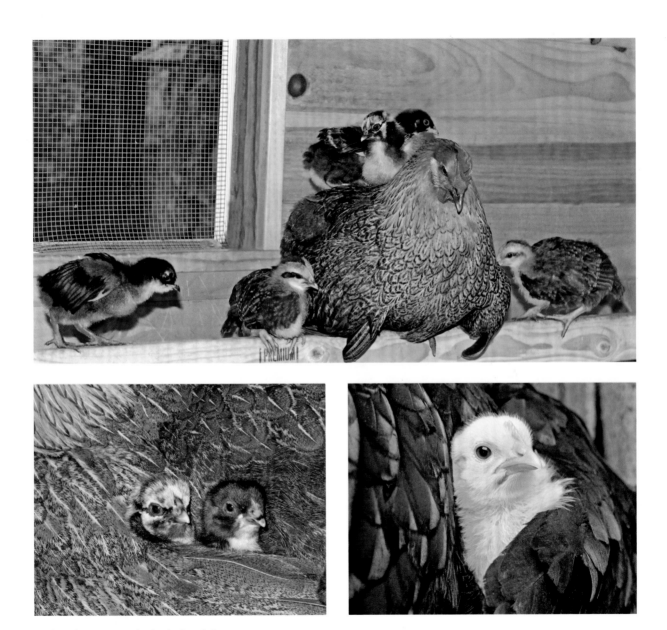

Nothing beats a warm feather bed made by Mom.

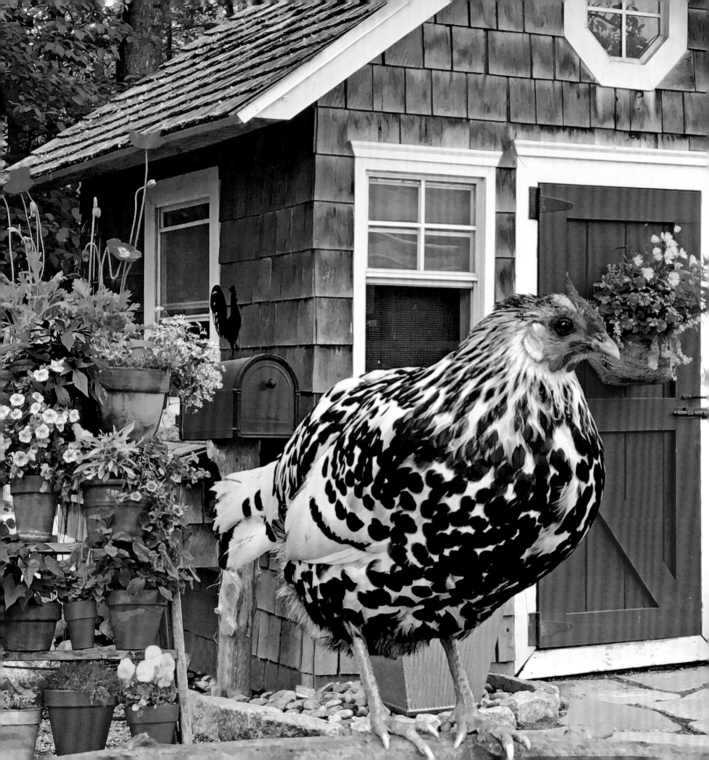

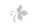

CHAPTER 2

The Ladies

My girls are poster chicks for diversity, emblematic of the truth that beauty comes in all shapes, sizes, and colors. They are always camera-ready in the ever-changing backdrop of my chicken yard.

OPPOSITE: Shelly, Silver Spangled Hamburg

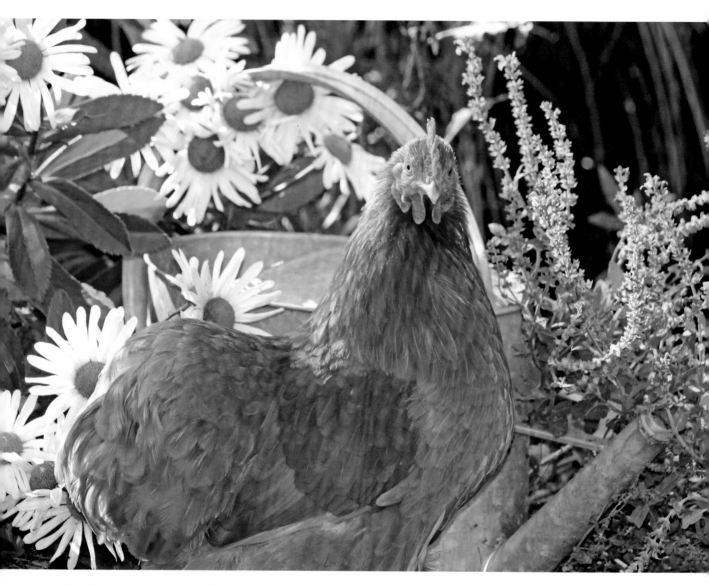

Creative container gardening and hardy perennials planted in the ground and surrounded by rocks or pavers to prevent destructive digging are terrific solutions for adding fabulocity to any chicken yard.

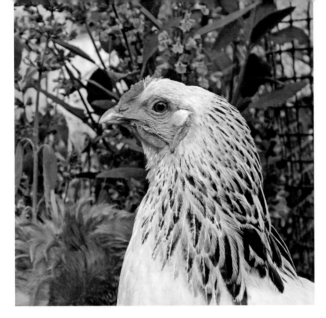

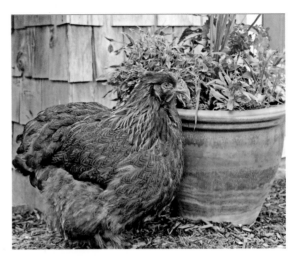

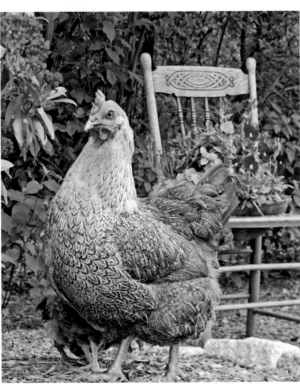

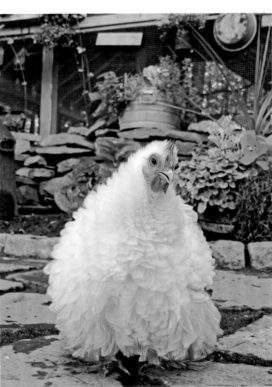

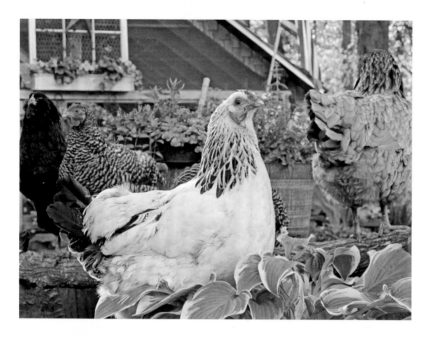

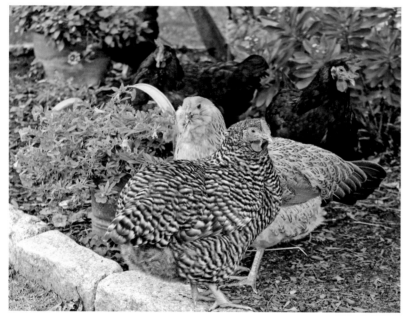

If scratching and pecking were athletic events, my ladies would undoubtedly be on the cover of *Sports Chicks Illustrated*.

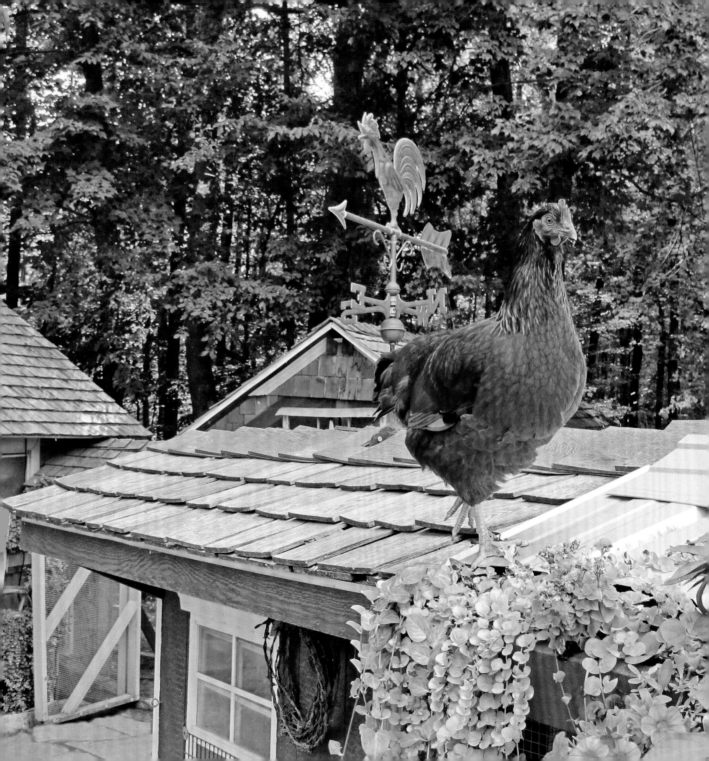

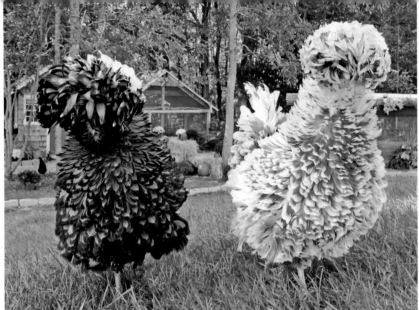

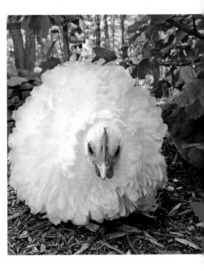

OPPOSITE: Scarlet is a low-maintenance girl who just can't understand what takes some of the other ladies so long to get ready for happy hour on the roof.

33

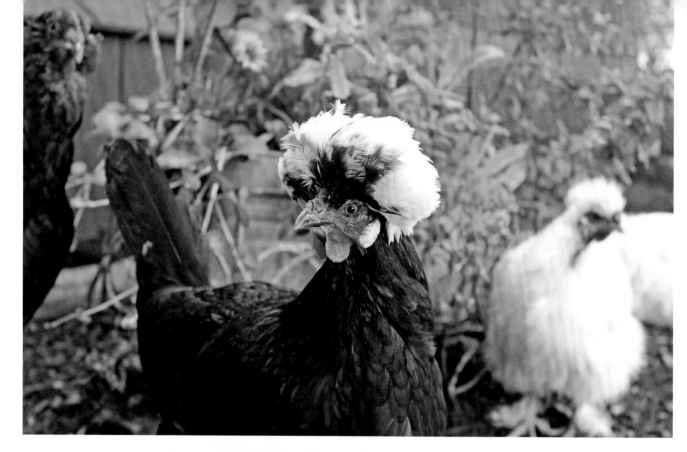

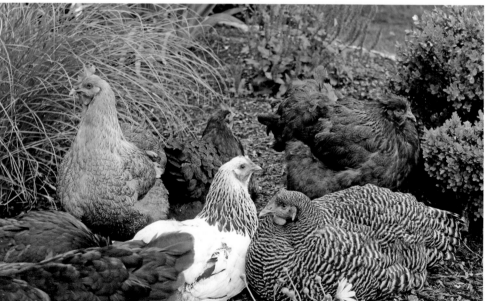

OPPOSITE: Portia would like to remind everyone to stop and eat the flowers. I'm sure she meant *smell* the flowers.

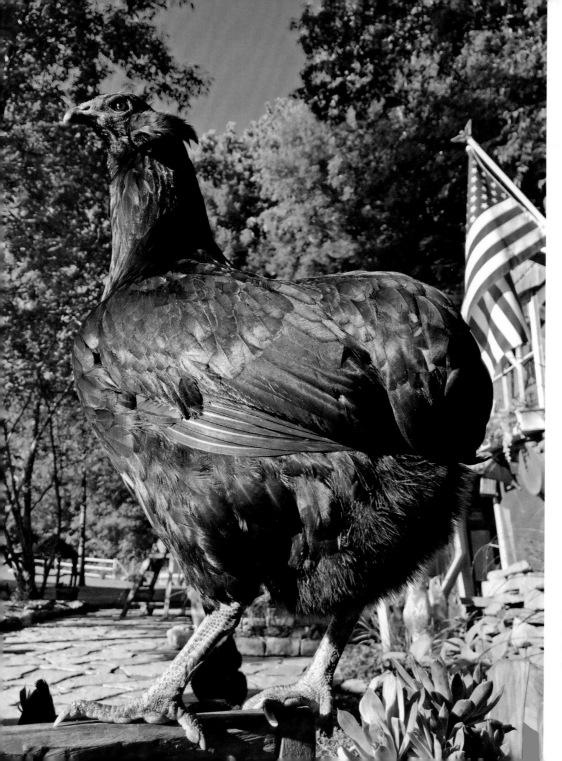

My ladies are proof
that beauty comes
in all sizes, shapes,
and colors!

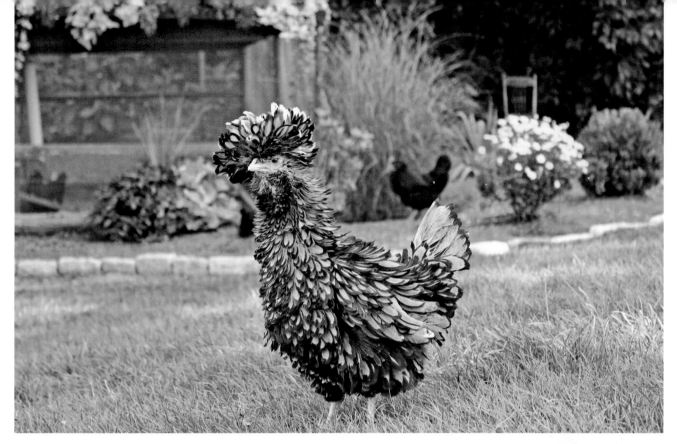

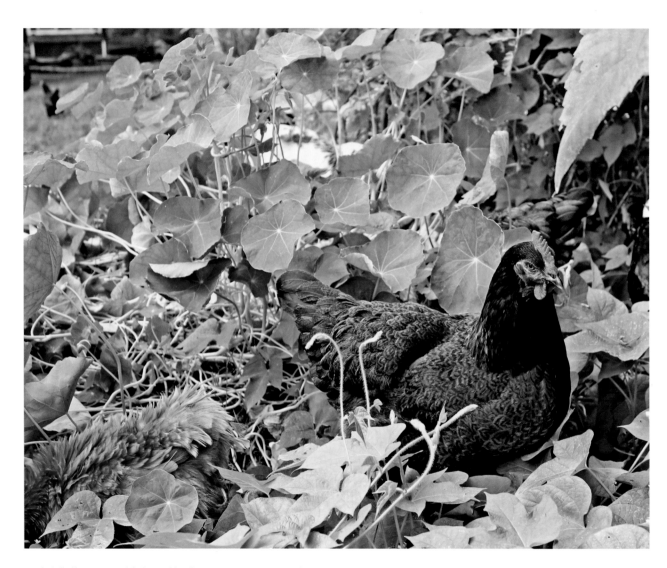

Rachel (left) tries—and fails—to blend into my nasturtium garden.

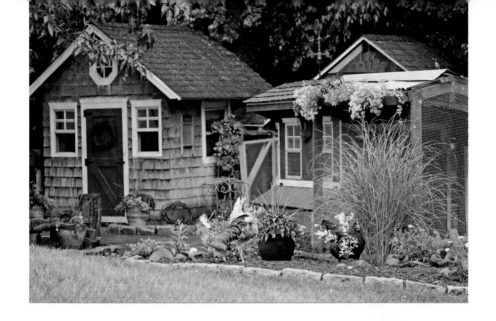

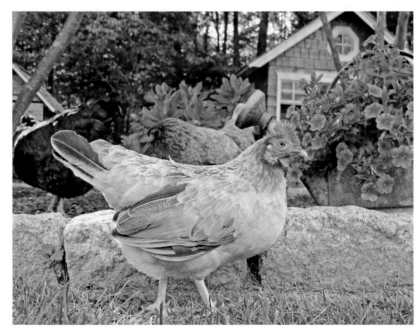

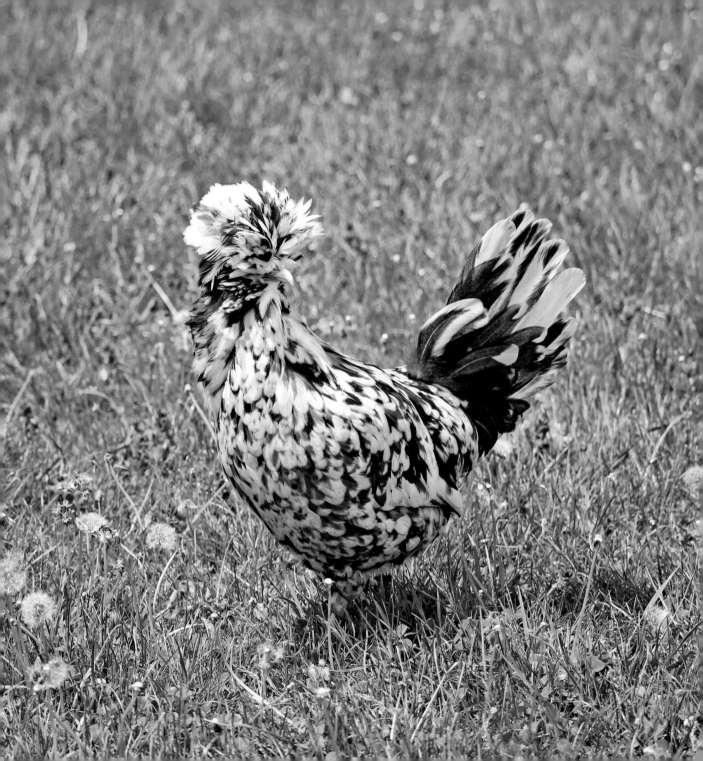

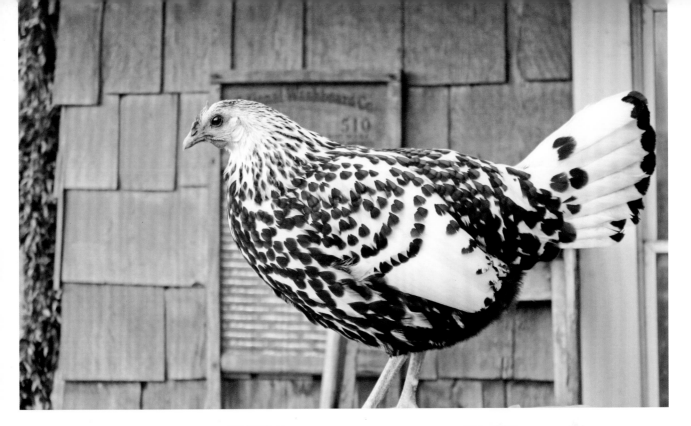

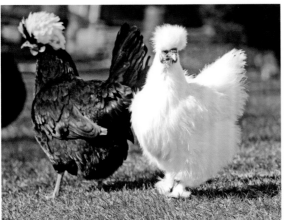

Starlets in black and white.

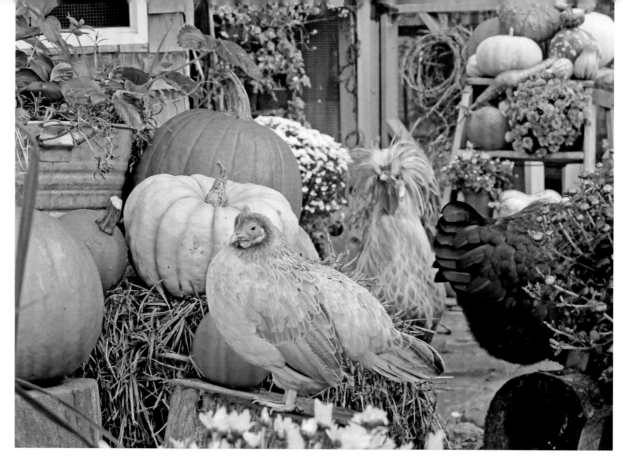

Autumn in New England offers a reprieve from the summer heat and brings a stunning new palette of colors to the chicken yard.

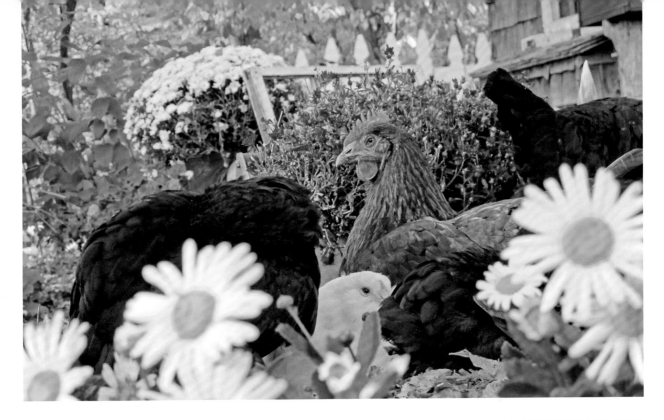

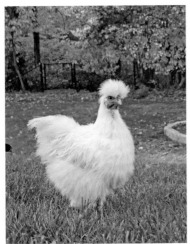

OPPOSITE: Yes, they're real. Try not to stare at their fabulocity—it makes her self-conscious.

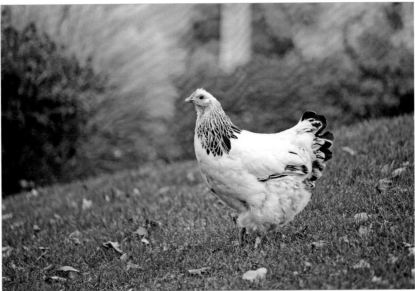

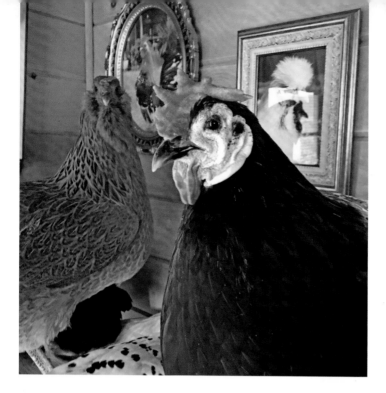

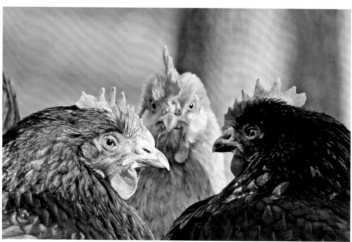

BOTTOM: Two of the "Hens in Black" huddle up for a little pecking-order gossip.

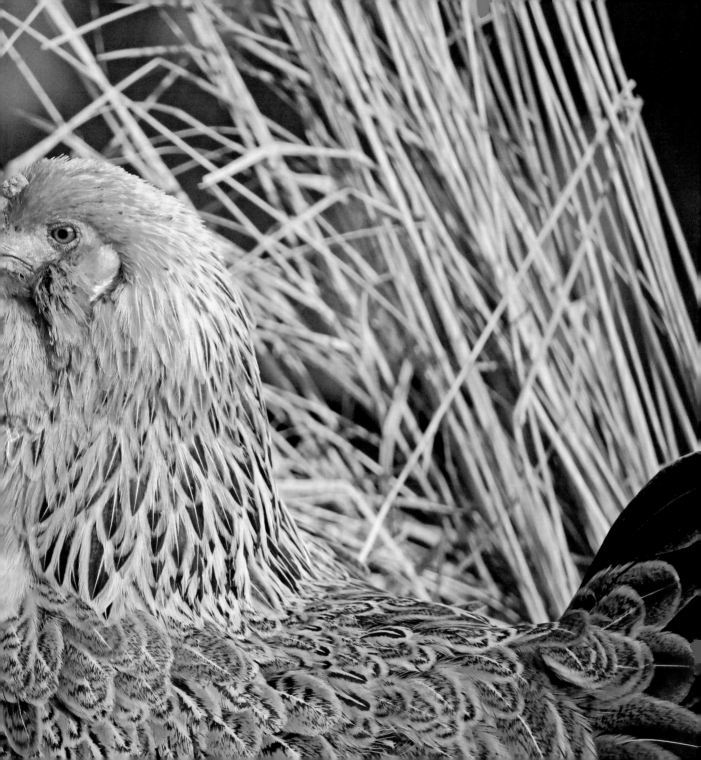

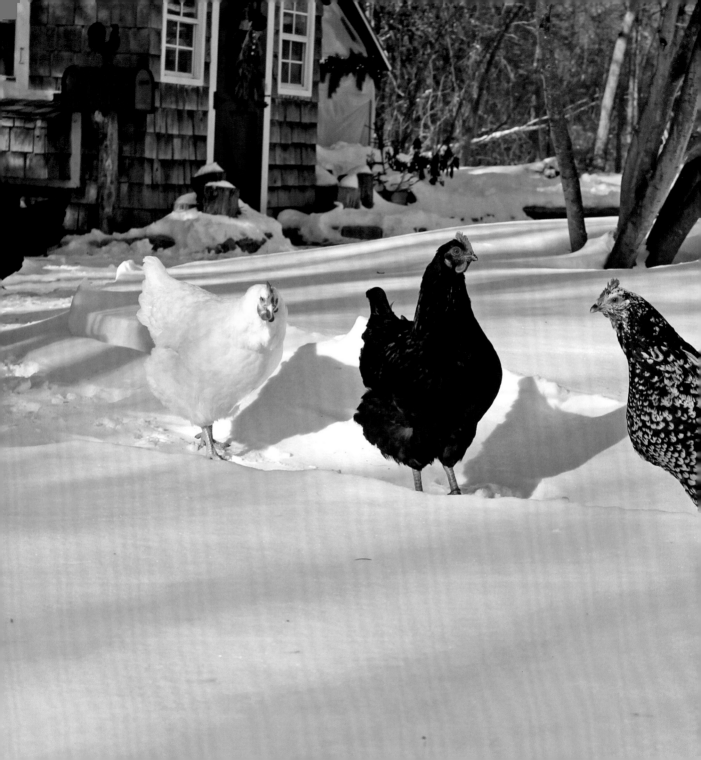

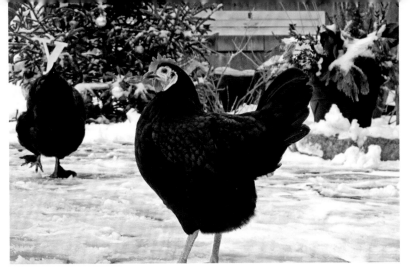

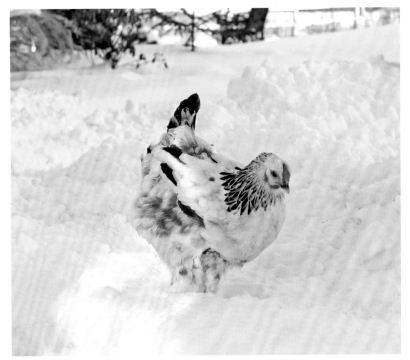

This is why sensible birds fly south for the winter.

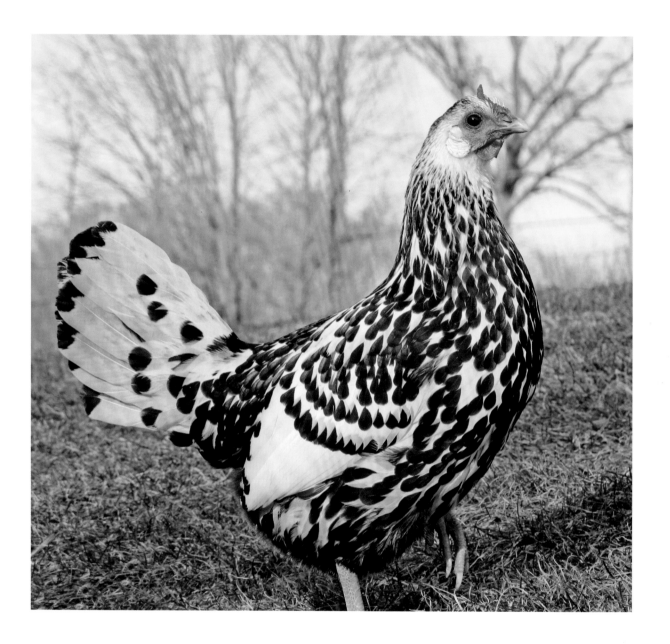

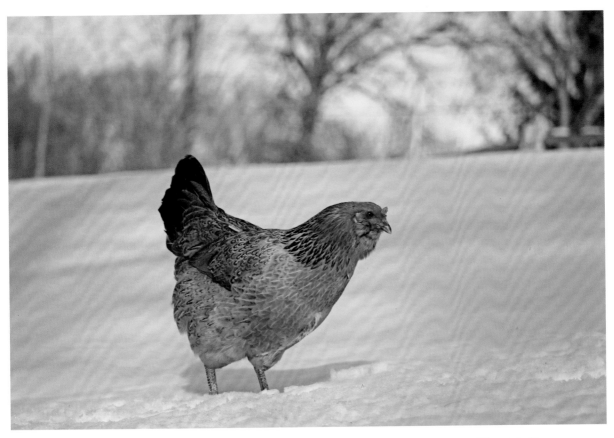

The original lawn ornaments.

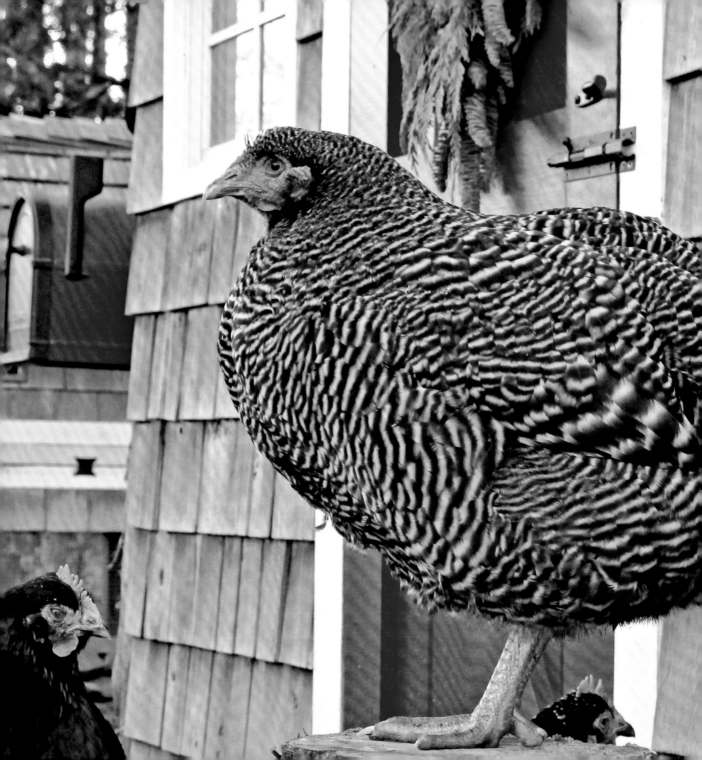

My lovely ladies are festive holiday decorations in their own right.

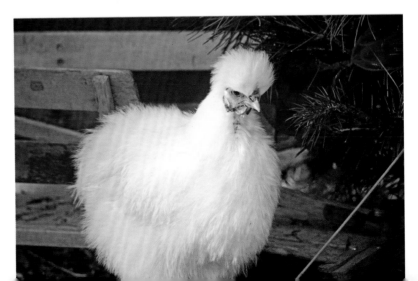

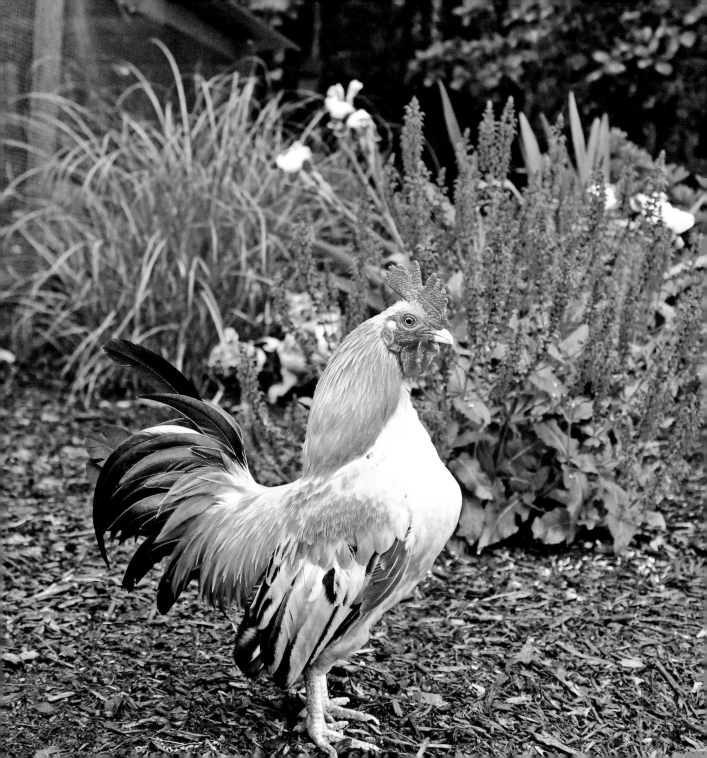

CHAPTER 3

The Boys

Yes, the ladies are lovely, but don't think for a moment that they've got the market cornered on eye candy! My boys are not only gorgeous specimens of feathered finery, they are also dutiful keepers of flock harmony and fierce protectors of the family. Regardless of their size, make no mistake: all my boys are large and in charge!

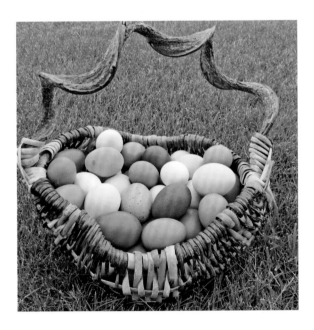

OPPOSITE: Caesar, Serama

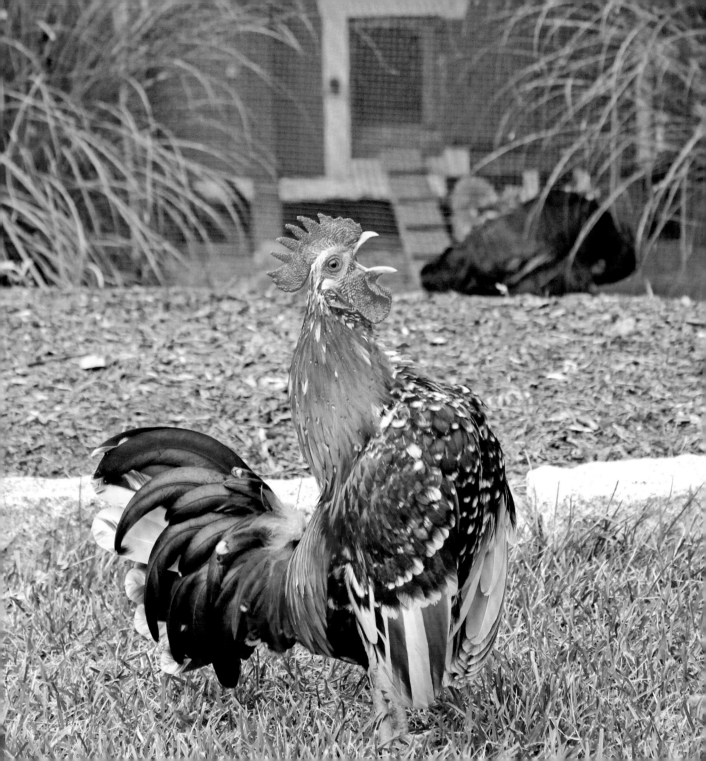

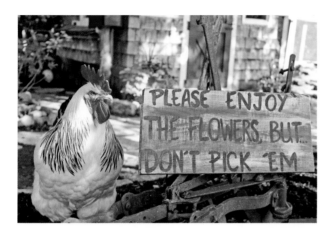

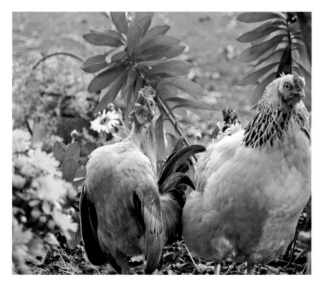

"It's 5 a.m. and you're trying to sleep? Allow us to sing you the song of our people!"

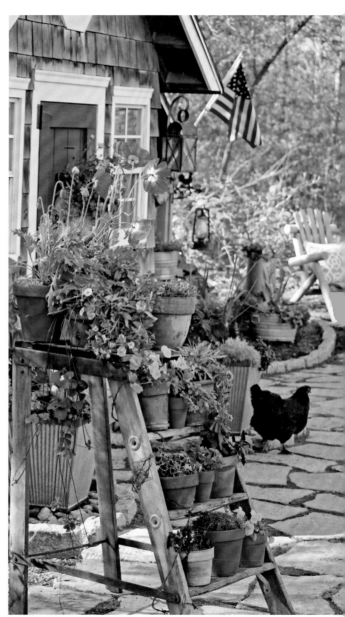

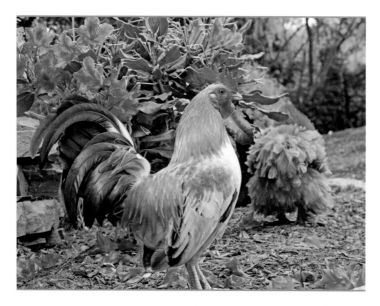

Caesar (above) and Blaze
(right and opposite) happily
shared flock security duties.

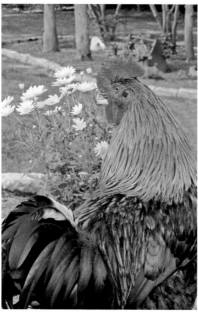

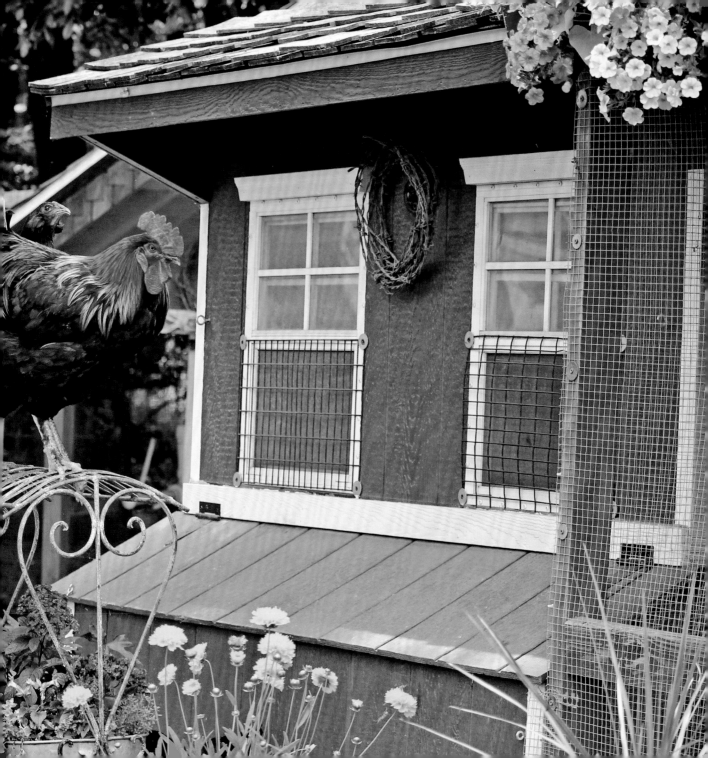

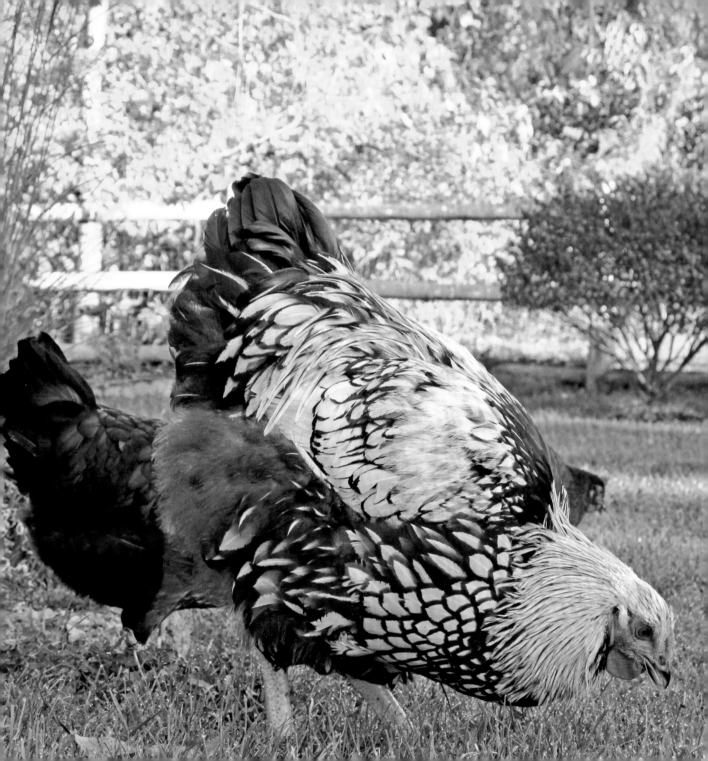

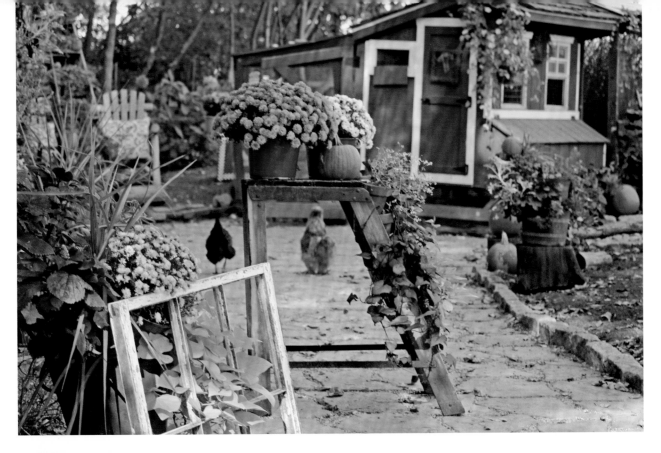

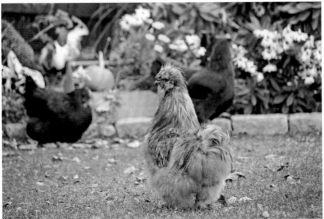

When autumn colors fade, fabulous feathers take center stage.

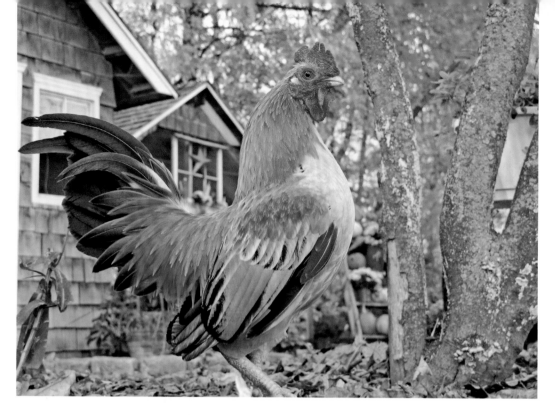

Don't let the stern looks
fool you—my boys are as
sweet and docile as they
are statuesque.

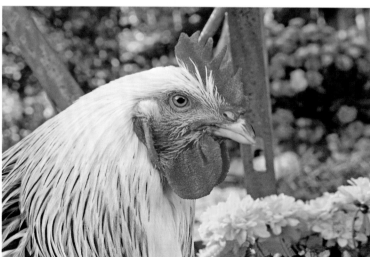

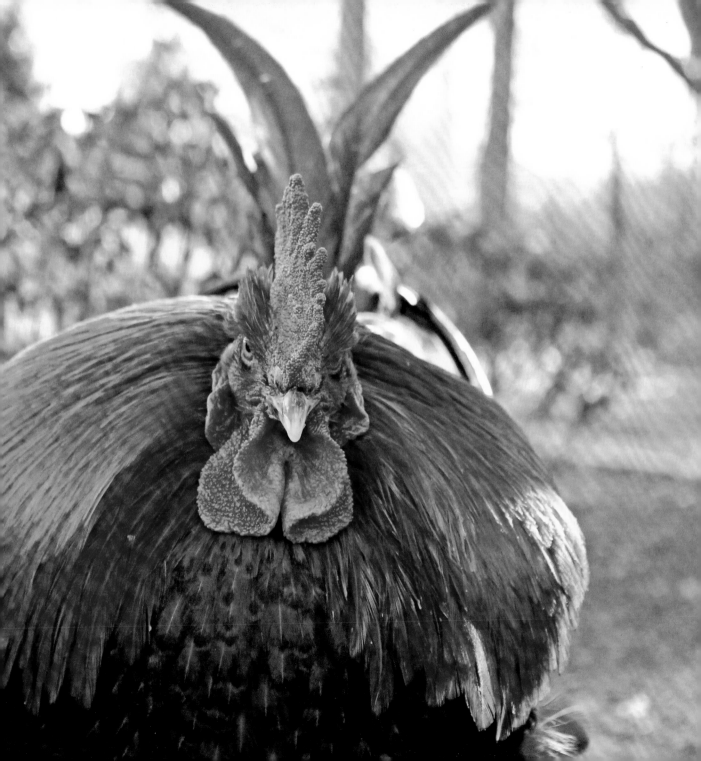

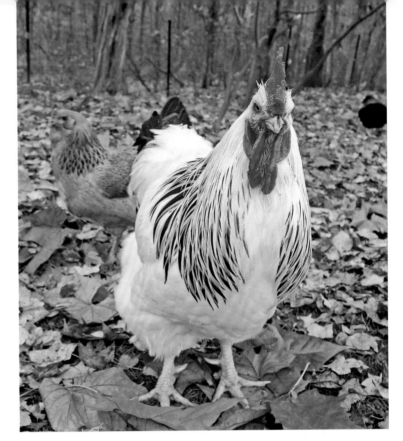

As long as each rooster respects the positions of the others in the social hierarchy, there is peace in the village. My boys ordinarily get along, but when conflict erupts, we find one of them a flock of his own with no competition.

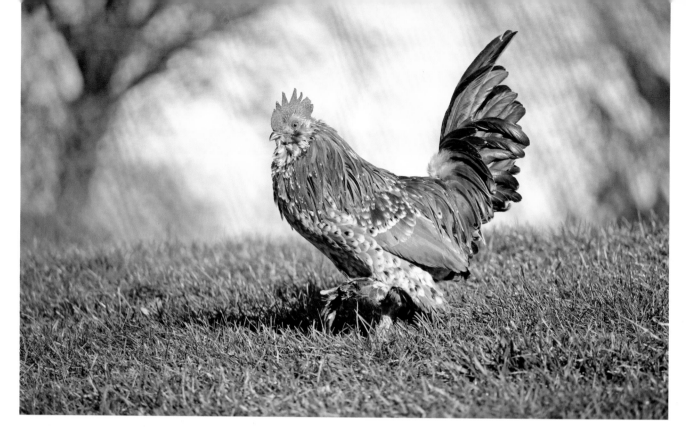

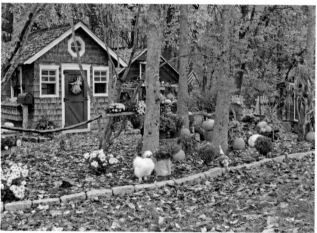

The Dukester (above) shows off his fancy feathered boots while Sherman (opposite) wonders where he might find a pair in black and white.

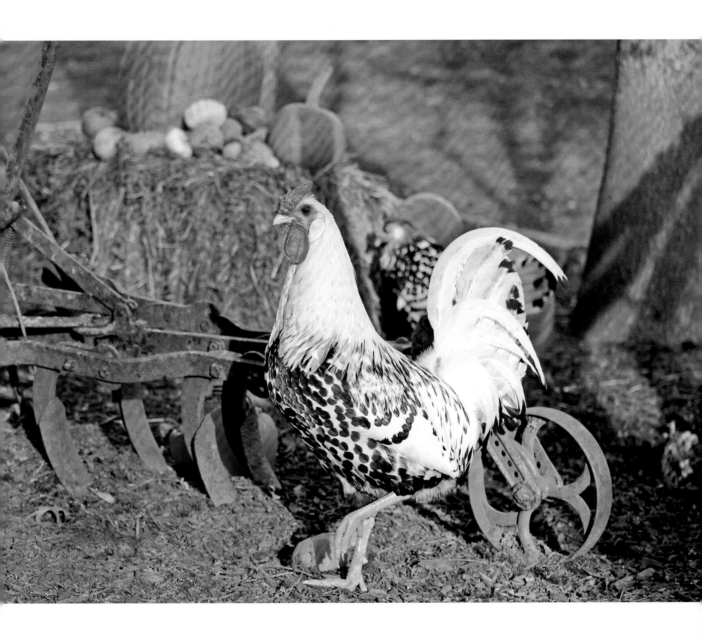

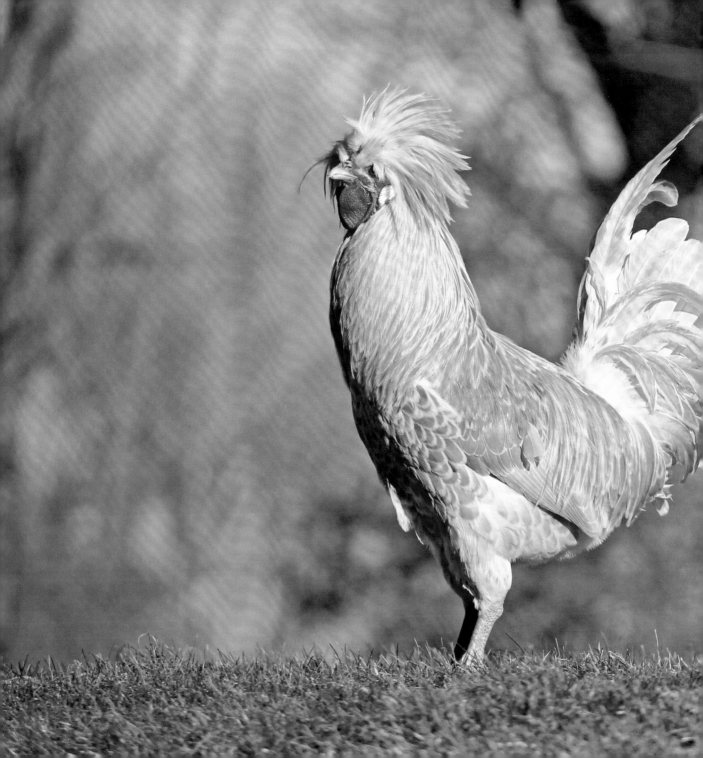

Every hen's crazy 'bout a sharp-dressed roo.

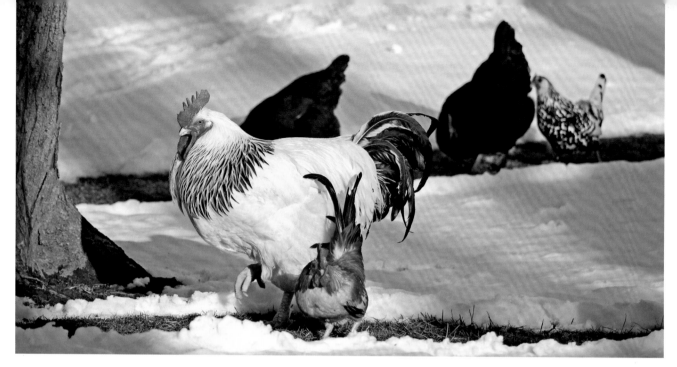

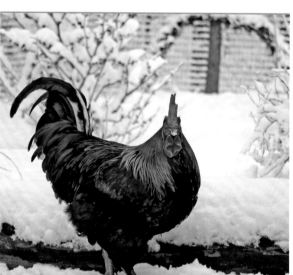

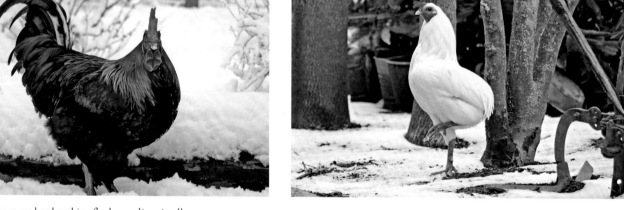

My boys are hardworking flock guardians in all seasons.

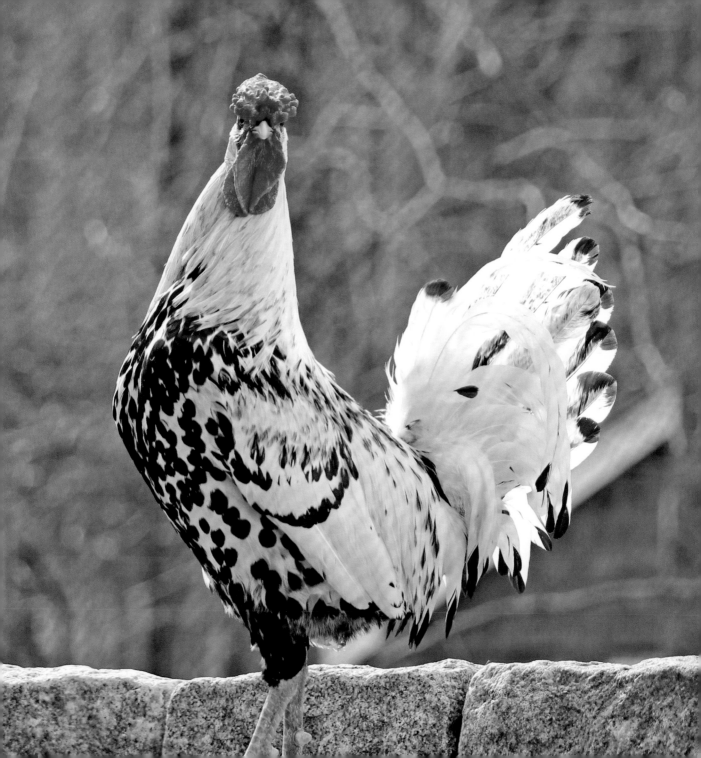

Christmas in the chicken yard is always such a beautiful time of year. The eggs may be few and far between, but they're appreciated that much more when we find them in the nest boxes.

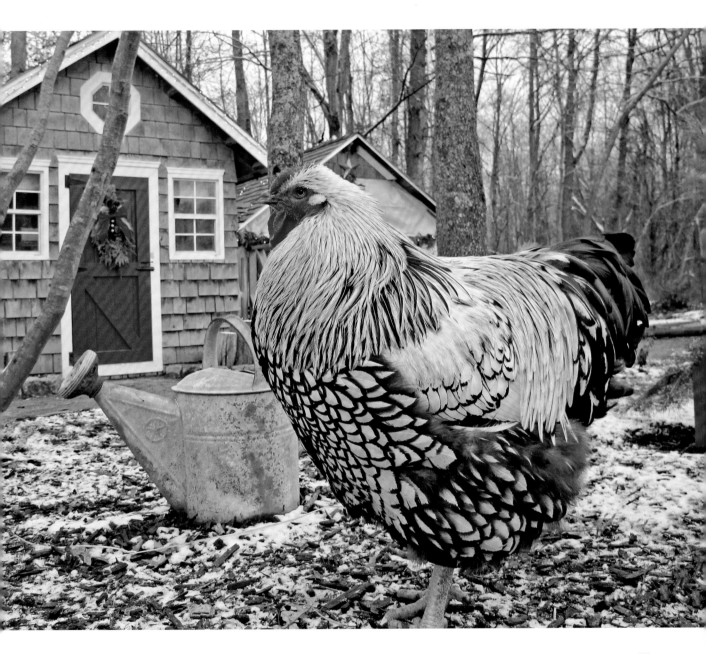

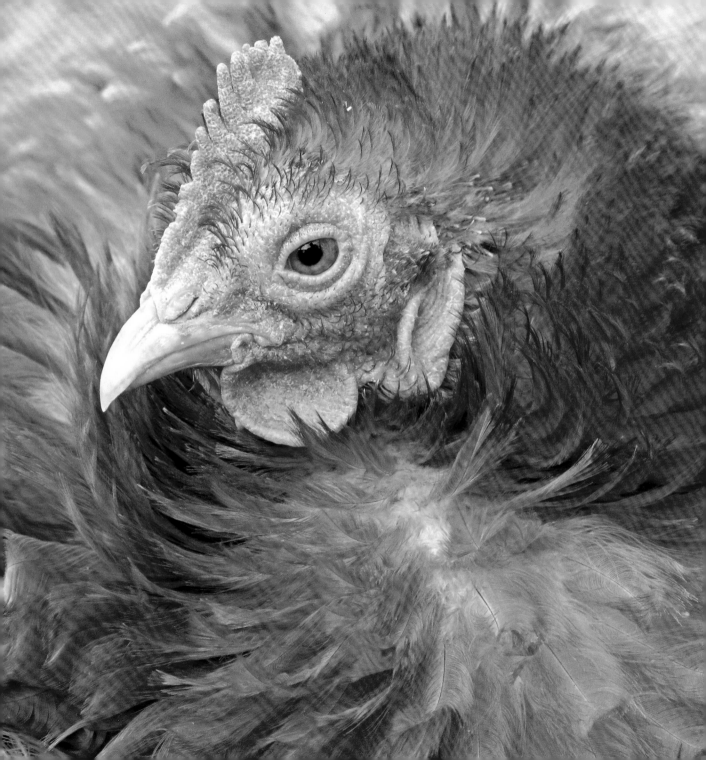

Rachel, the Diva

Rachel was a soulful little ginger hen who changed perceptions of what a chicken is.

Her daily appearance on my Facebook page became as familiar and comforting to many as the first cup of morning coffee or a loved one's kiss goodnight. She meant different things to different people. There was something in Rachel that everyone could identify with, relate to, or aspire to become.

She was also a diva. Despite being a flock animal, she was unapologetically independent, spirited, opinionated, expressive, graceful, feisty, clever, irreverent, and rebellious. Her larger-than-life personality belied her diminutive stature. She and Blaze, a dashing Black Copper Marans rooster, shared a romance for the ages and came to be known as "The Royal Couple."

All who waited for her daily photo identified with her in some way, whether through a common frustration, a shared pet peeve, a bad hair day, a personal victory, or a heartbreaking loss.

Rachel became an icon, and her legacy to the chicken world is carried on in each of us who loved her.

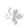

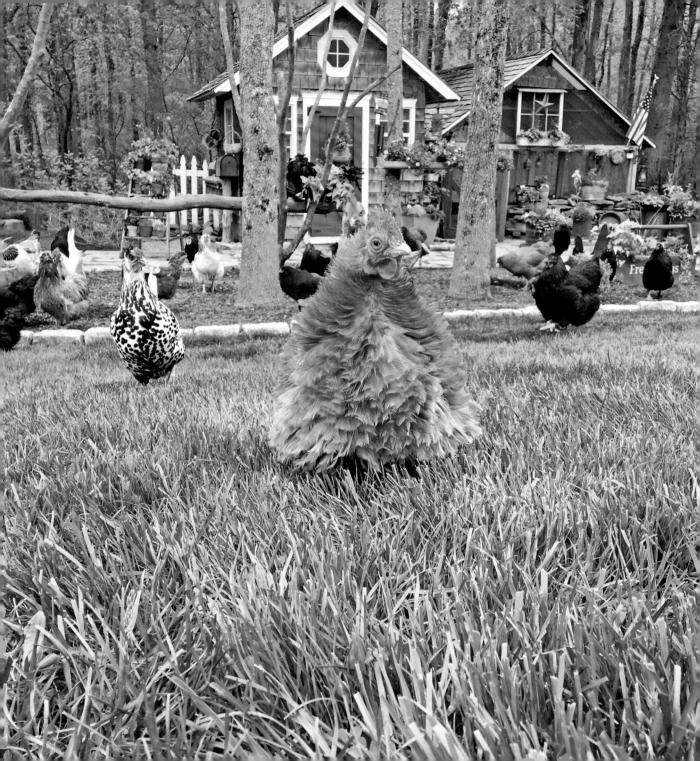

Rachel frequently could be found flanked by her bodyguards known as the "Hens in Black," who were the all-female, feathered version of the Secret Service.

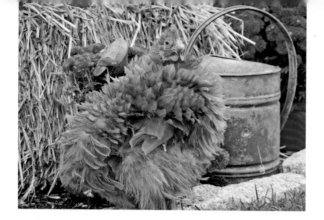

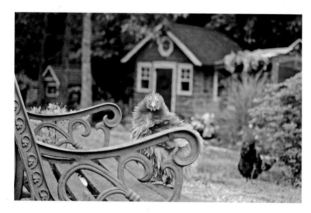

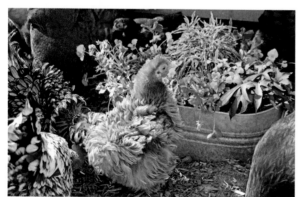

Mother Nature obviously used Rachel as her inspiration for the autumn colors.

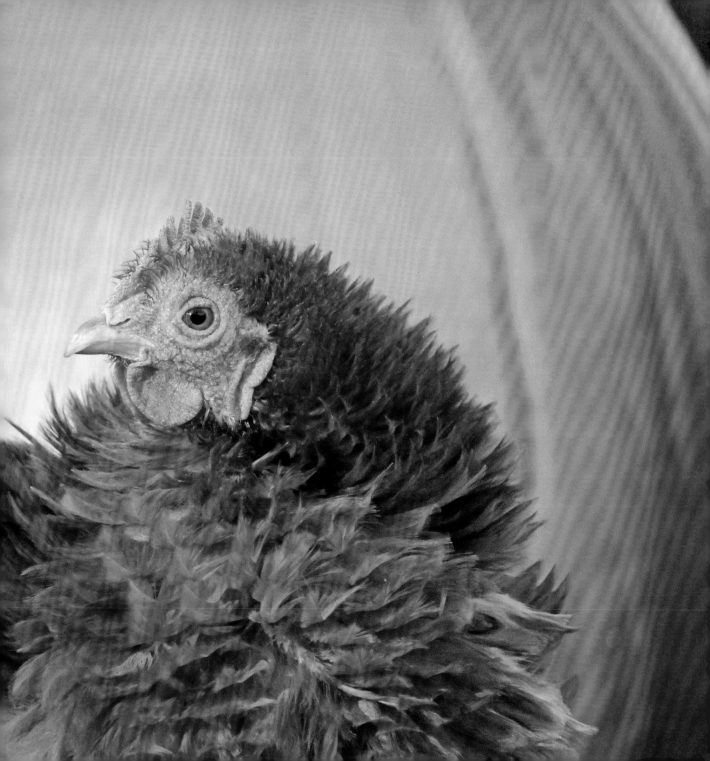

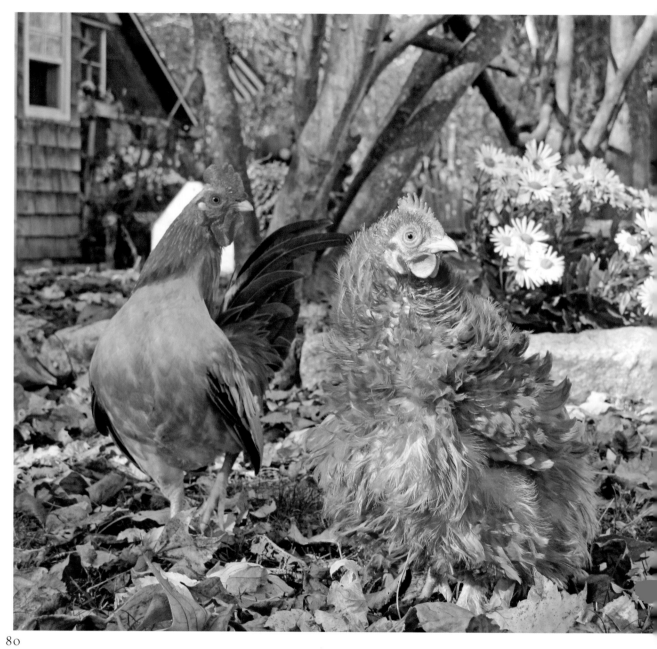

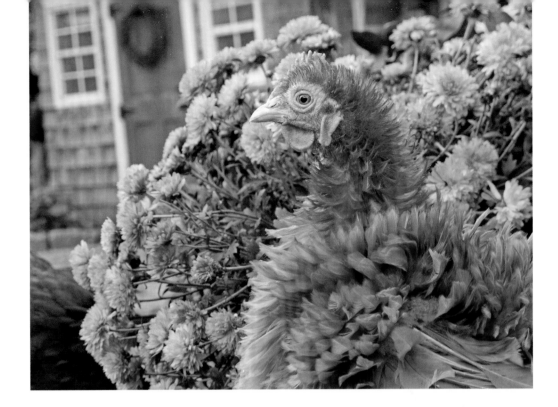

"And though she be but little,
she is fierce."

—William Shakespeare,
A Midsummer Night's Dream

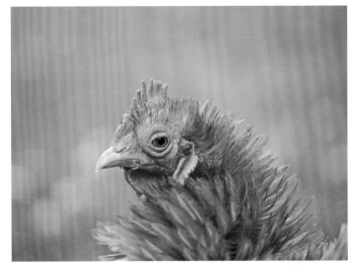

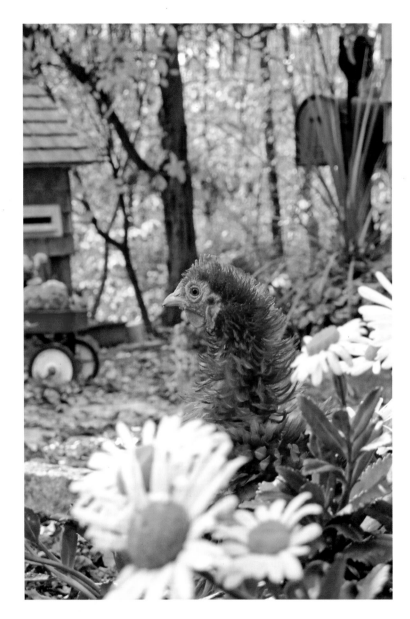

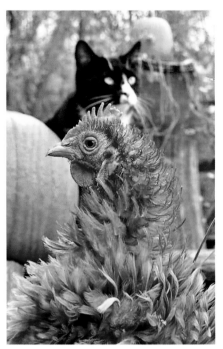

Rachel considered Freida (opposite) a close friend. Serena, our Tuxedo cat (above) . . . not so much.

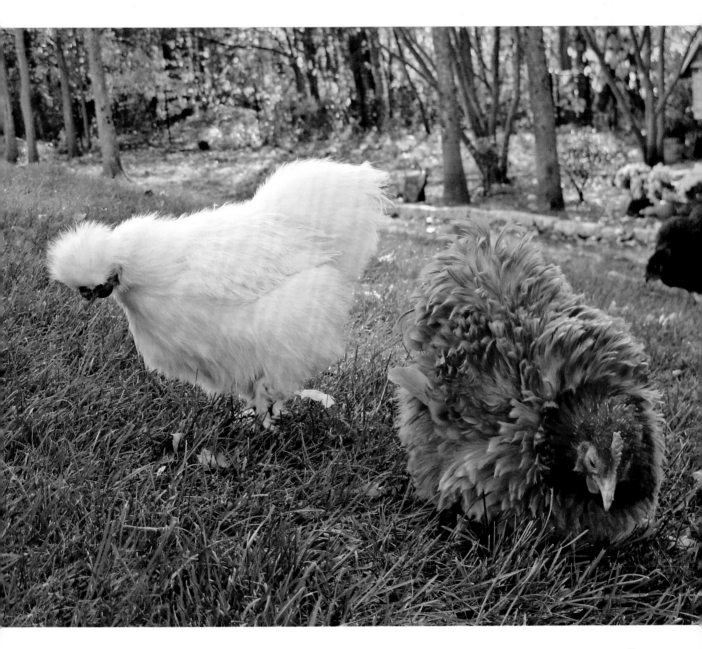

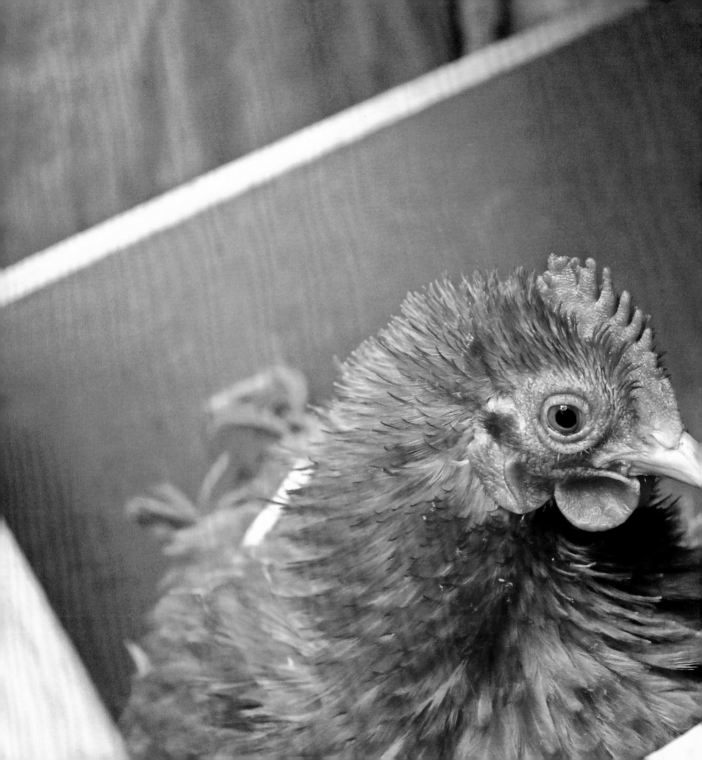

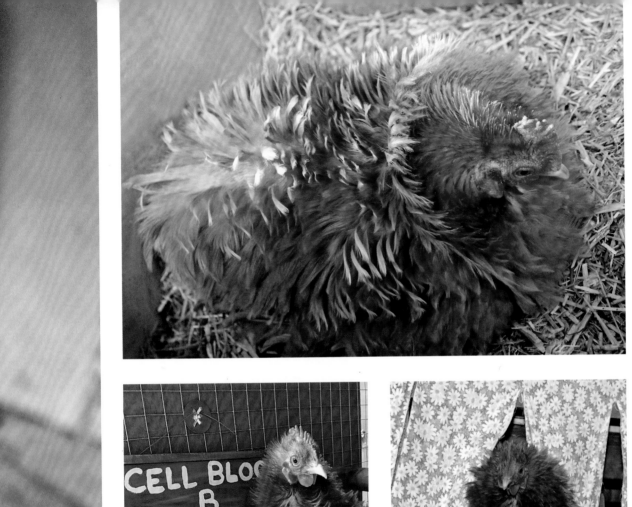

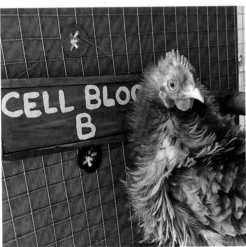

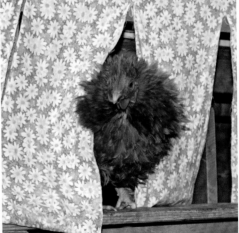

Rachel's hormones often insisted she sit in a nest, but she wasn't cut out for motherhood, so when she staked out a nest, she was relegated to Cell Block B until her motherly hormones cooled off.

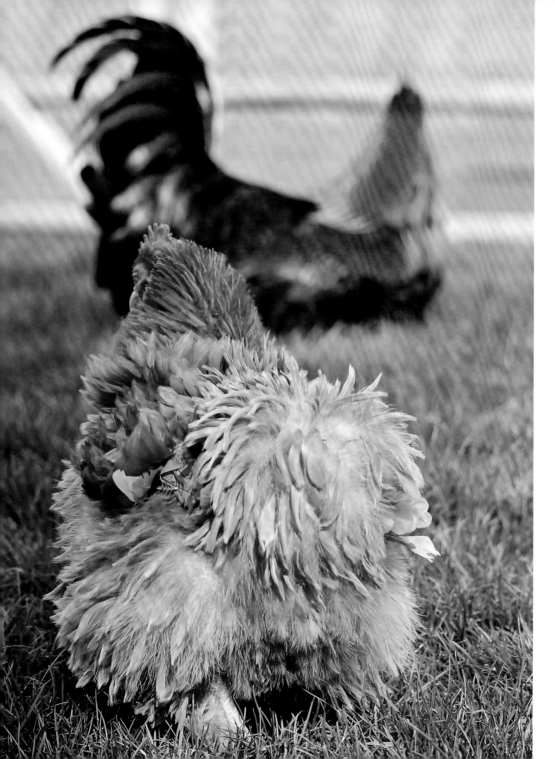

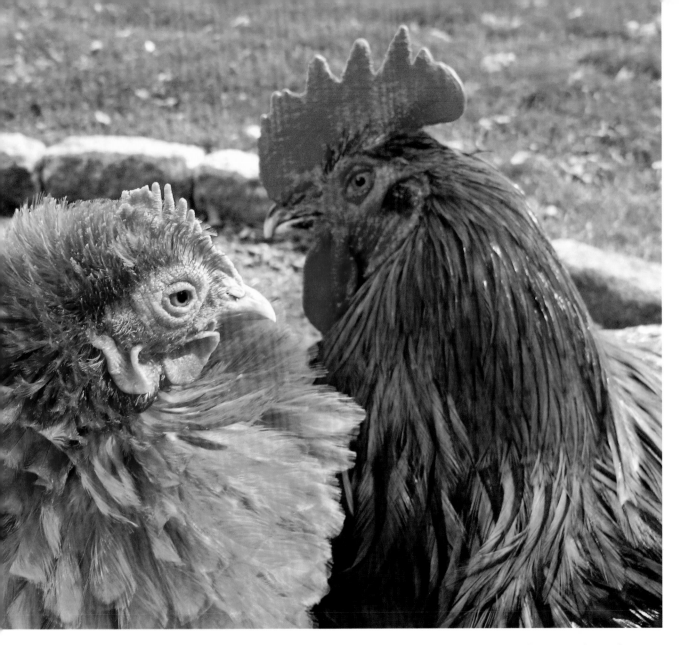

Rachel and Blaze were an unlikely couple, he at least twice her size and several years her junior. Yet they became known as "The Royal Couple" for their regal deportment and abiding affection for each other.

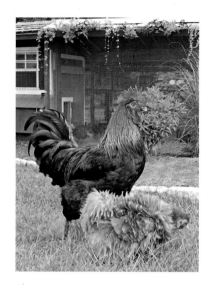

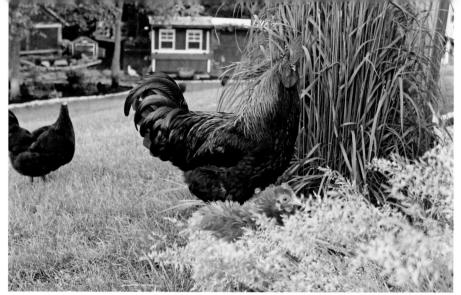

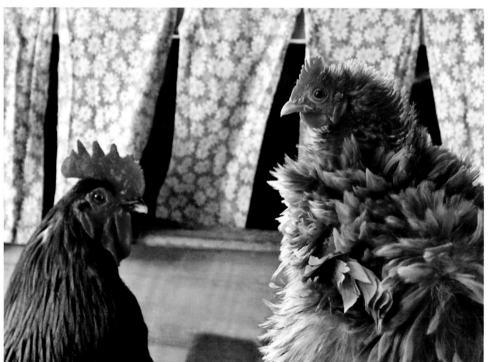

"Once in his life, every man is entitled to fall madly in love with a gorgeous redhead."
—Lucille Ball

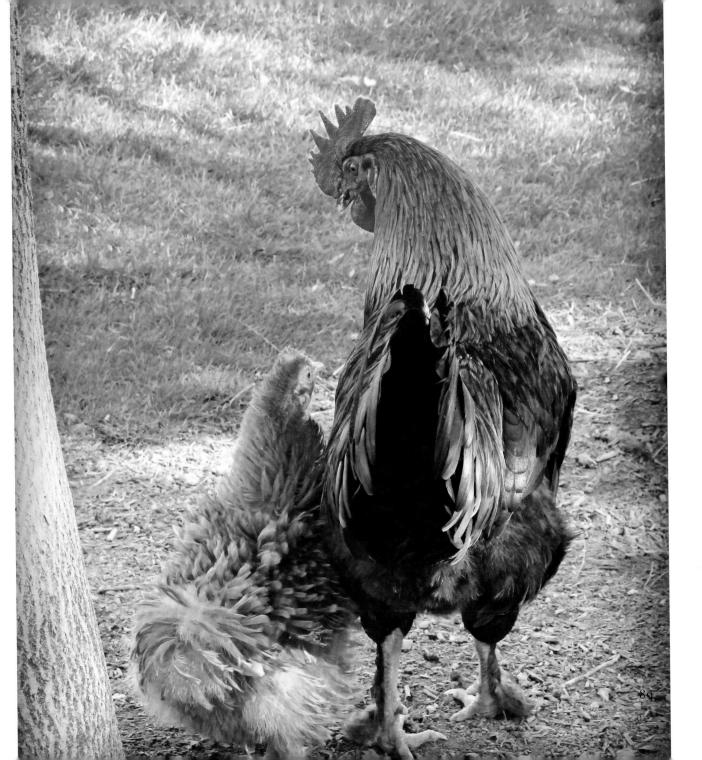

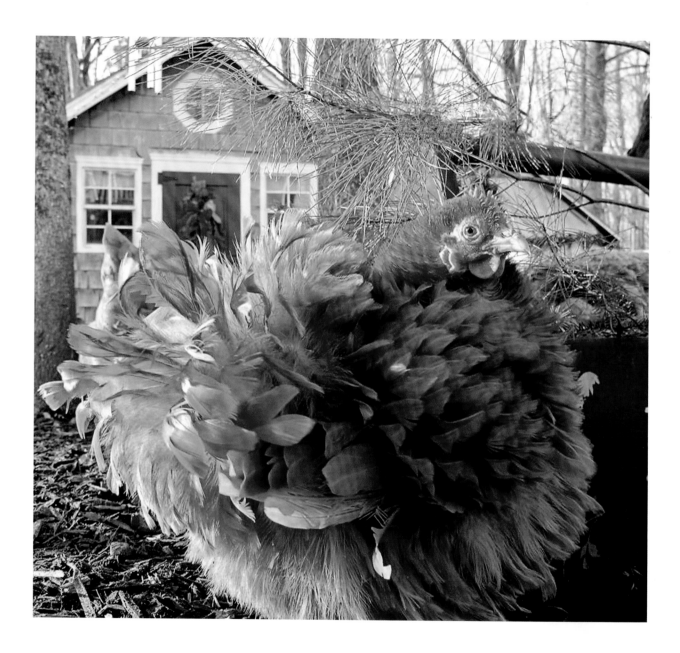

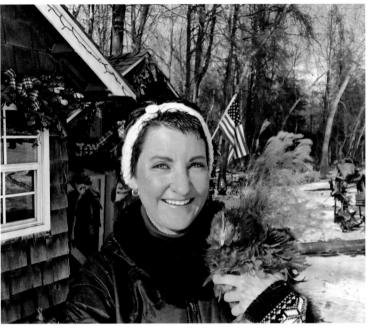

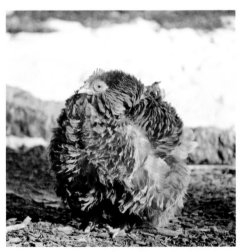

She wasn't much for the social scene, but Rachel would occasionally humor me with a selfie or a meet-and-greet with Milo, the new puppy.

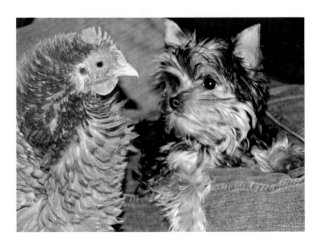

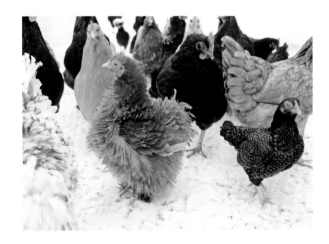

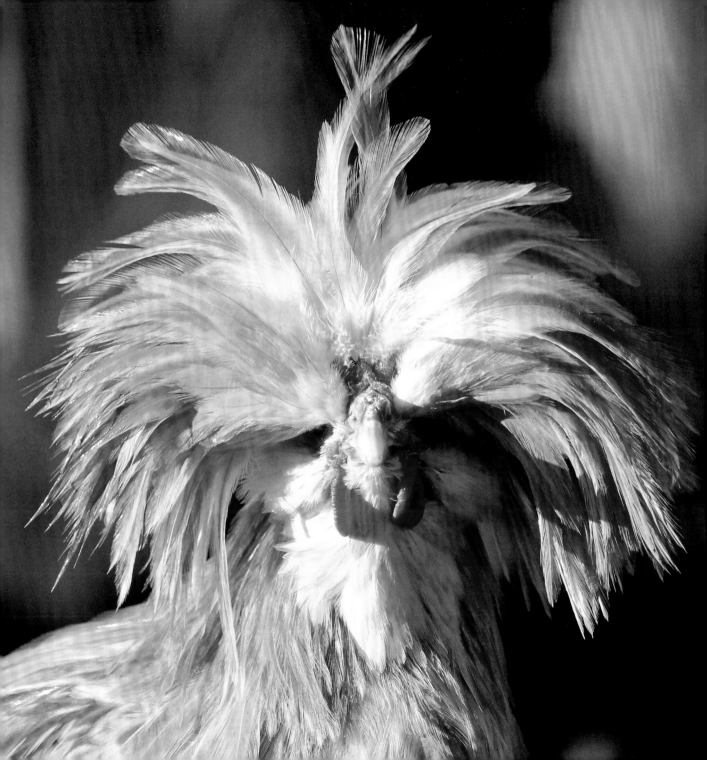

That Face!

Where *do* they learn the stink-eye, the puppy dog eyes, that over-the-shoulder glance, and the "it wasn't me eating the petunias" look? If a picture does speak a thousand words, please be careful when interpreting some of these expressions!

OPPOSITE: Siegfried, Polish

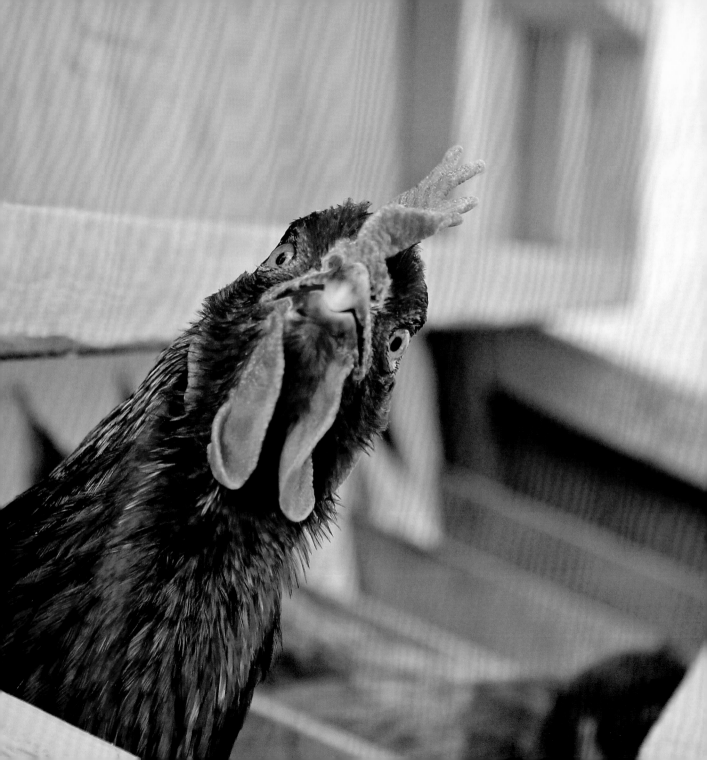

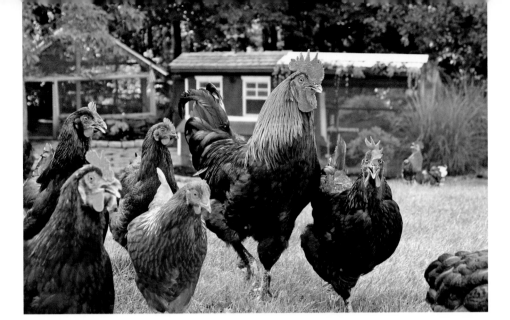

"Are we late for Happy
Hour with Hens?"

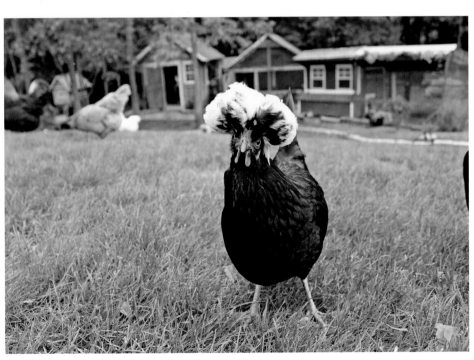

95

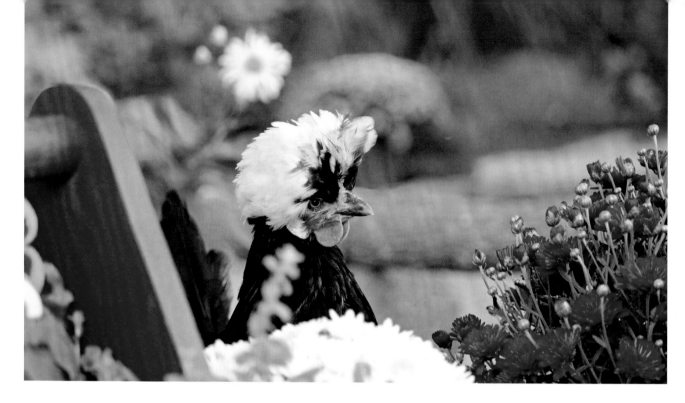

Being fabulous in front
of the lens can be hard
work for some, but
it comes naturally to
these ladies.

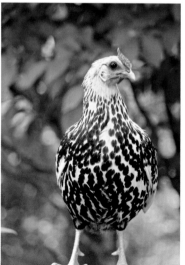

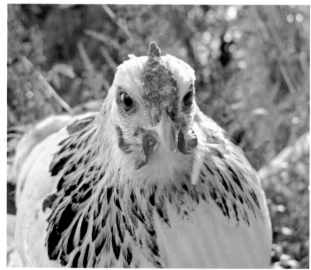

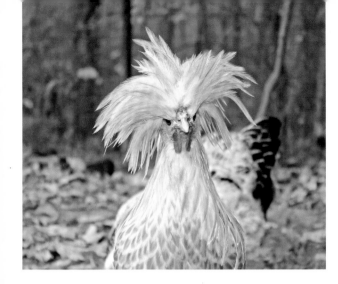

Some faces only a mother could love, but I don't know any chicken that meets that description.

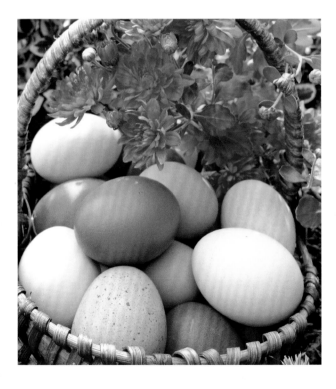

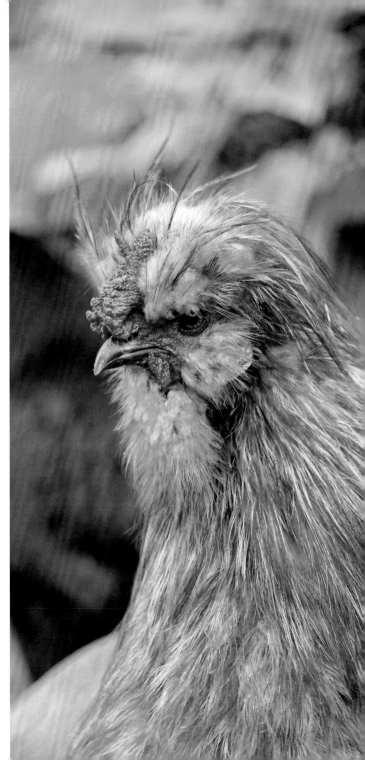

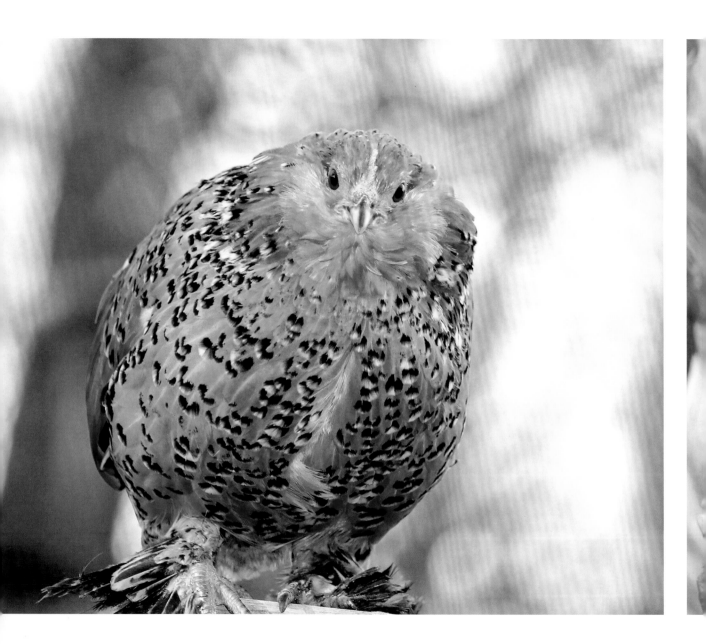

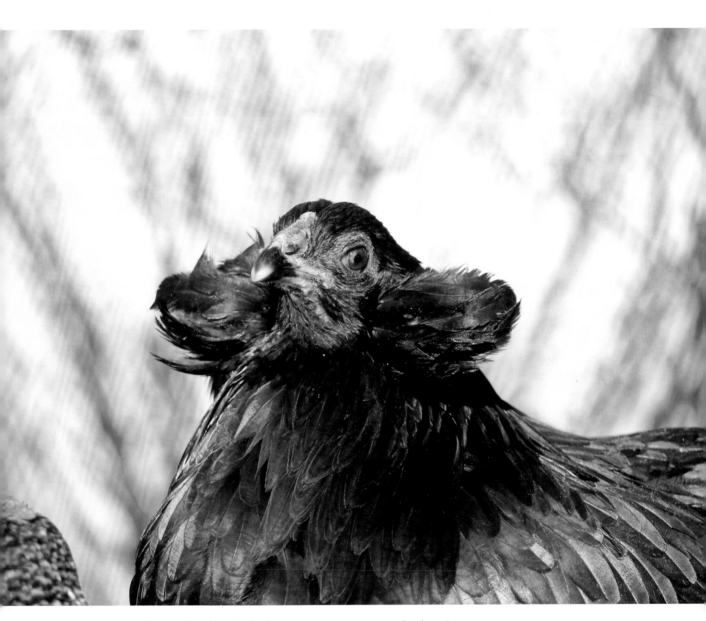

"Rachel got an entire chapter to herself in this book? Someone get our agents on the phone!"

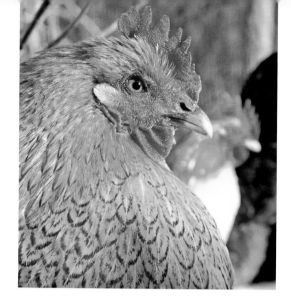

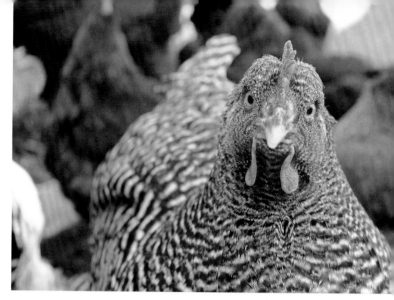

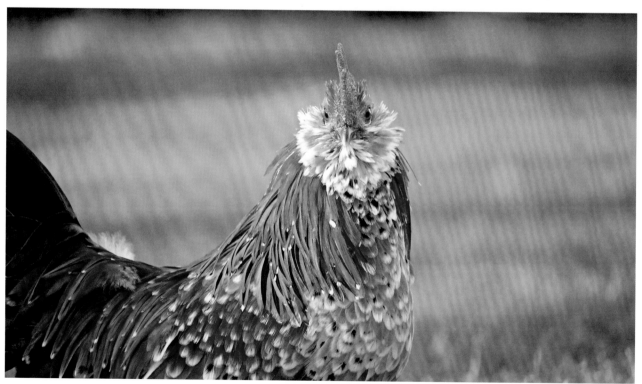

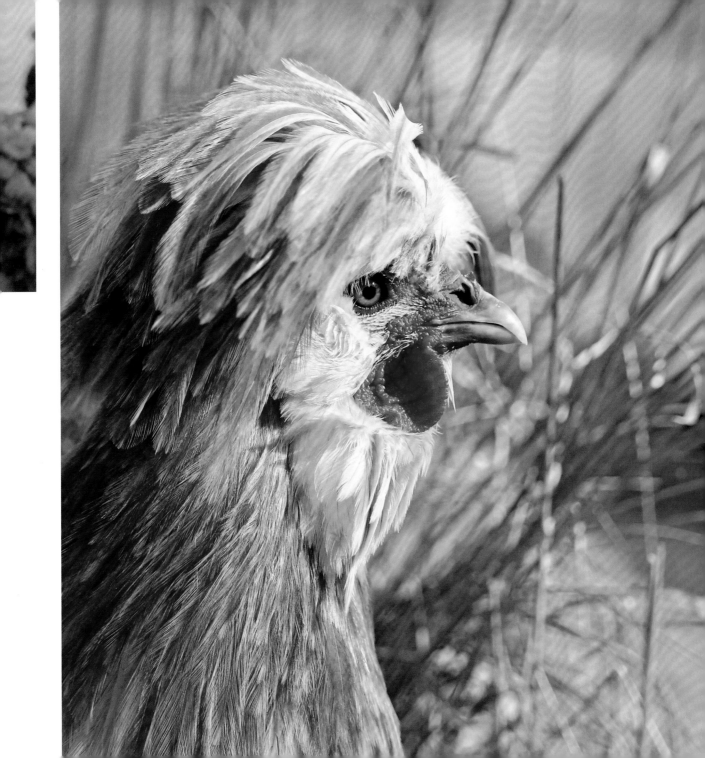

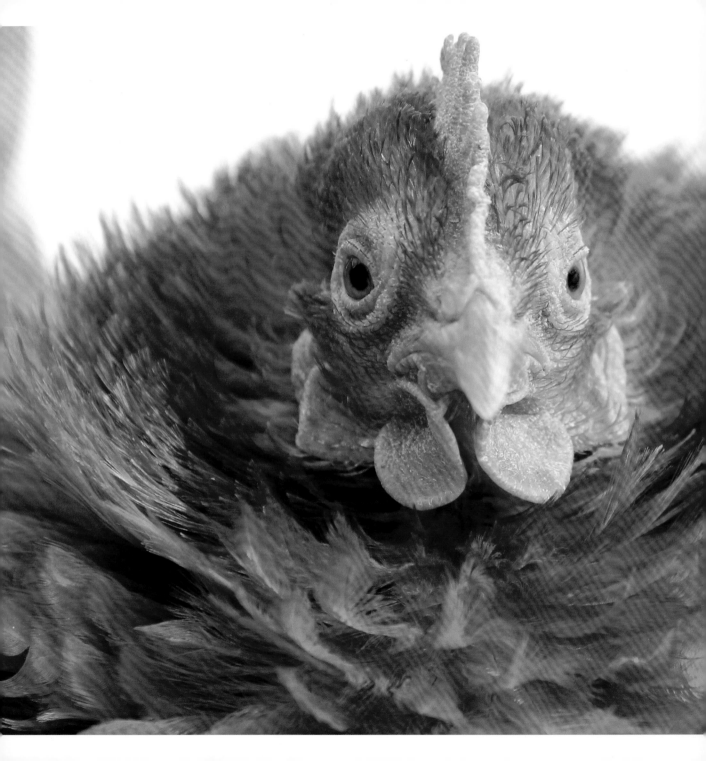

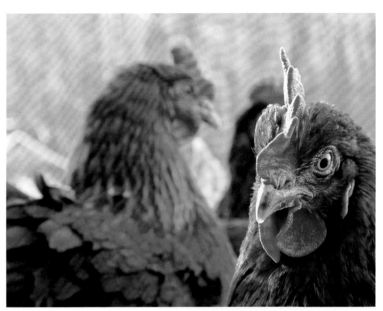

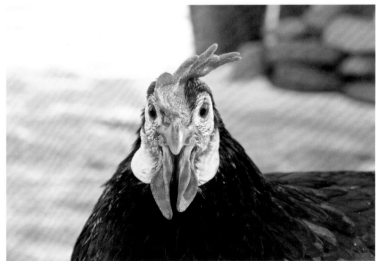

Two members of Rachel's security detail, the "Hens in Black" (top).

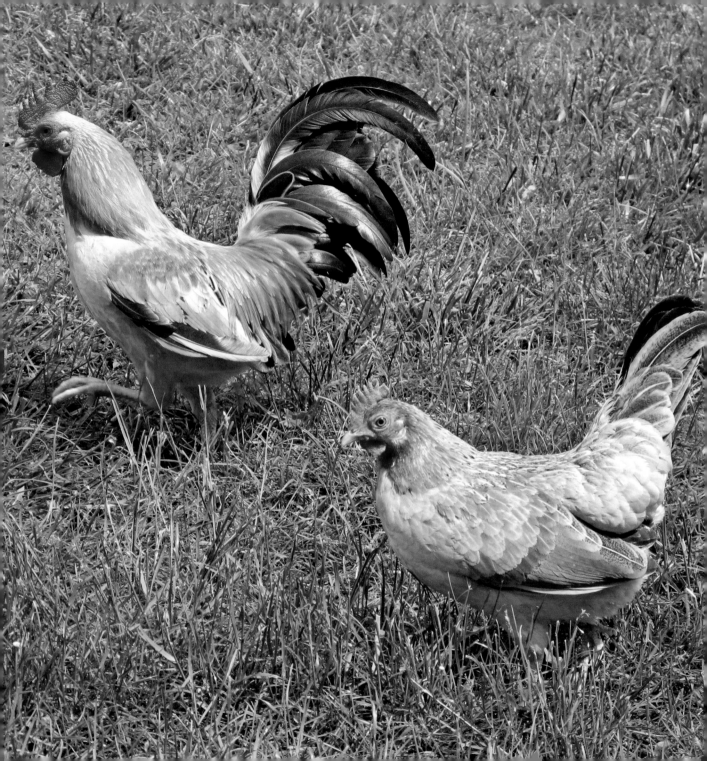

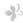

CHAPTER 6

Poultry in Motion

Chickens are graceful animals, but they certainly are capable of some awfully awkward moments too—scratching and pecking, squawking and crowing, wing flapping and tail wagging, and their courting and courtship avoidance, which can be poetic plumage ballets or cringe-worthy spectacles. In either case, capturing it on camera is worth the price of admission!

OPPOSITE: Caesar and Portia, Seramas

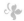

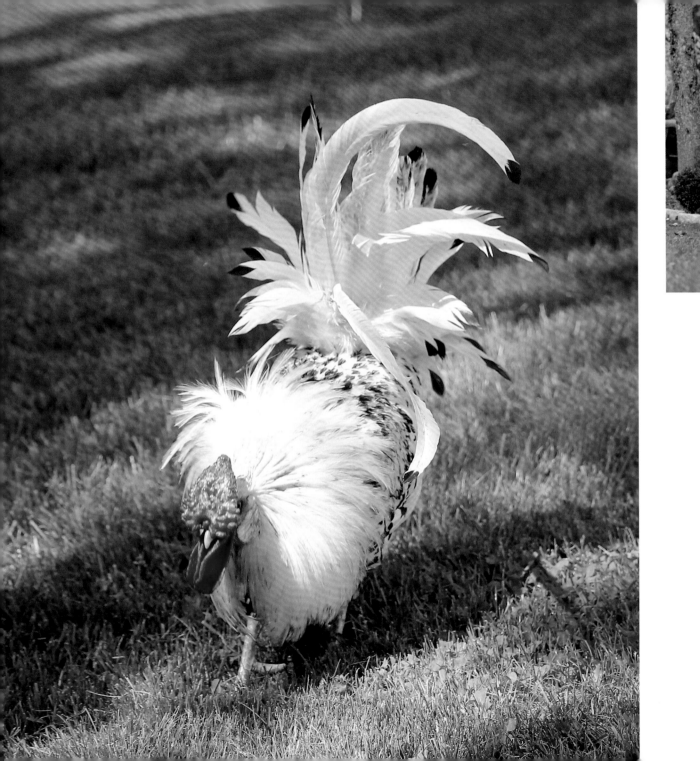

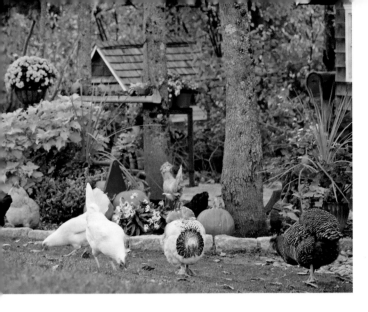

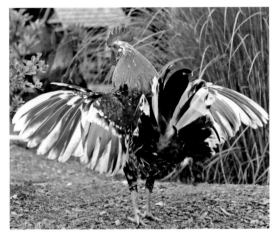

Sometimes, the chicken yard is much like an aquarium where constantly changing scenery floats past, offering similar therapeutic benefits to the viewer . . .

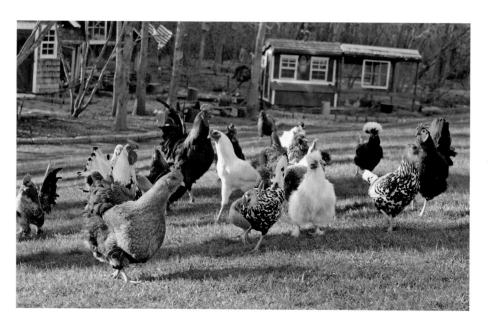

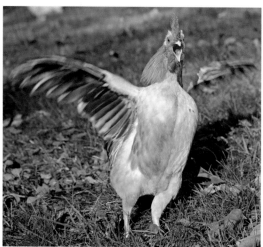

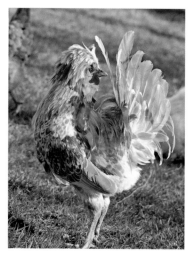

. . . other times the yard is more like a three-ring circus. But clowns are entertaining in their own way and laughter is the best medicine.

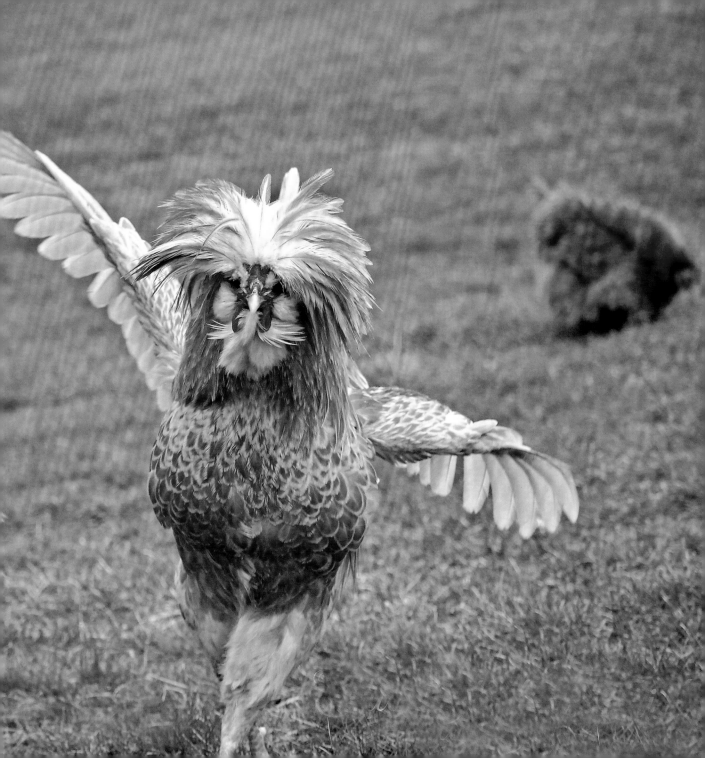

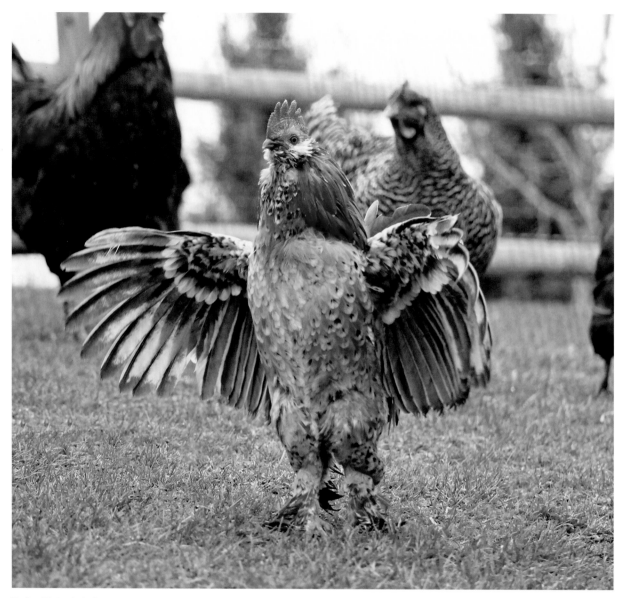

Duke: "Bring it in!"

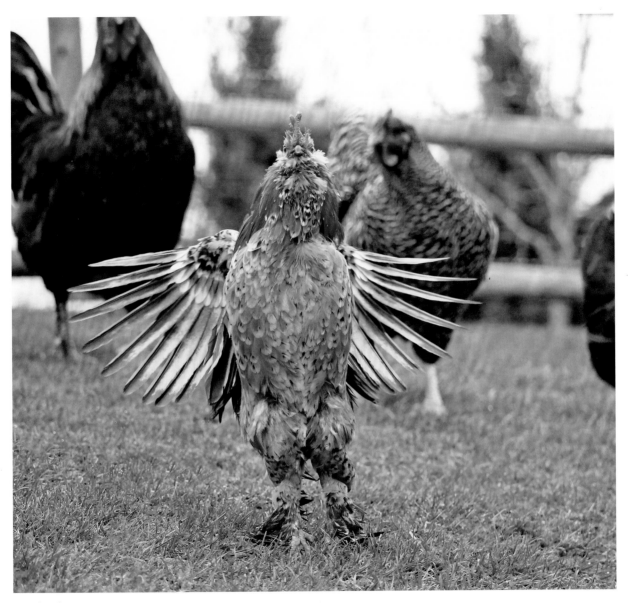

"Jazz hands!"

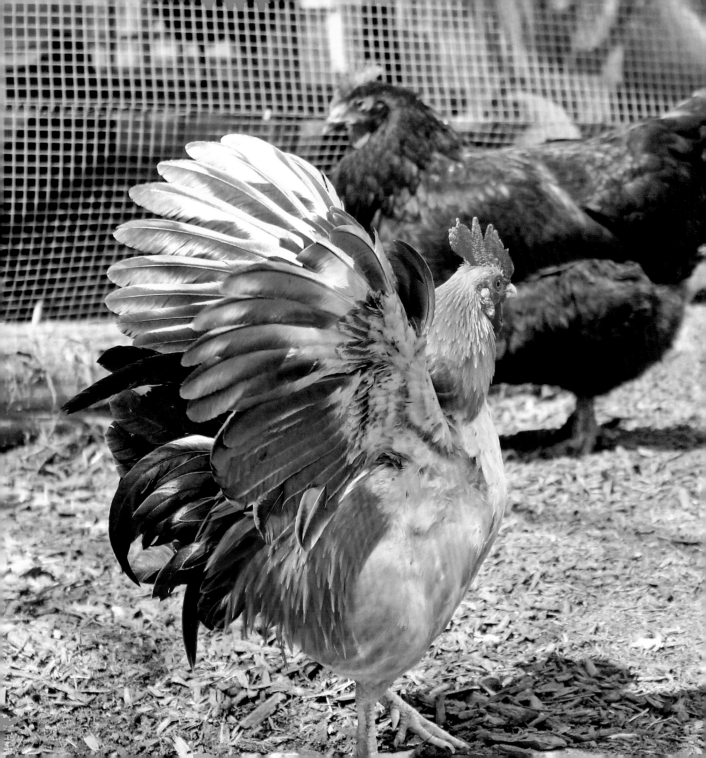

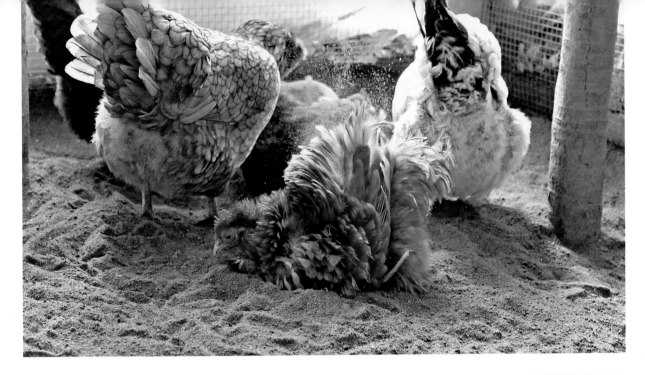

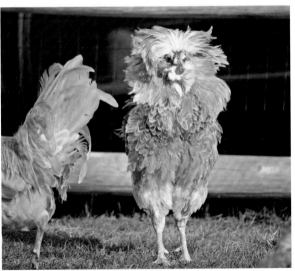

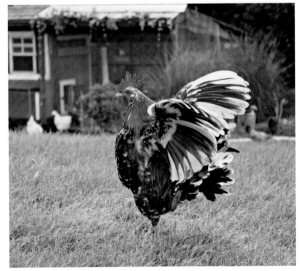

Caesar (opposite): "Talk to the wing."

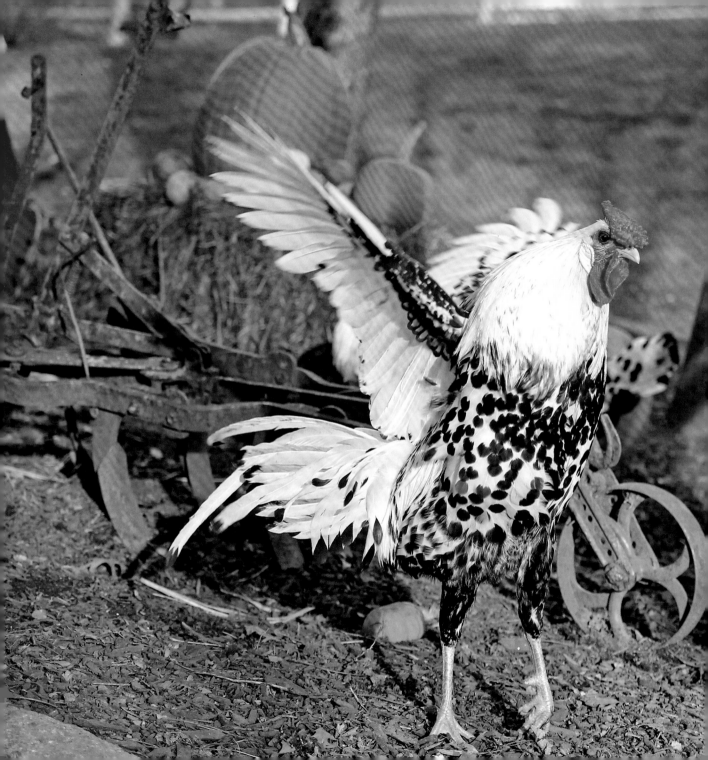

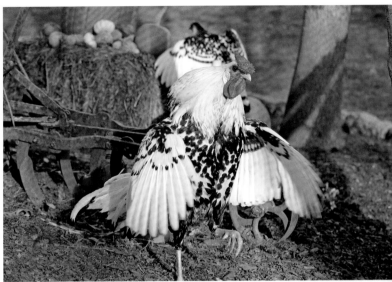

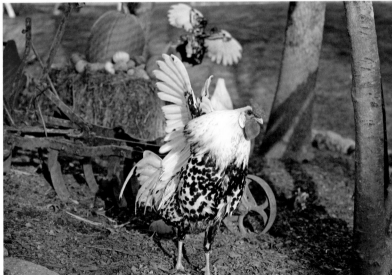

"It's fun to stay at the YMCA . . ."

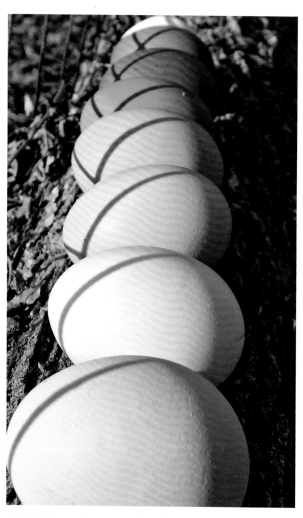

Rachel: "I just can't get away from the paparazzi."

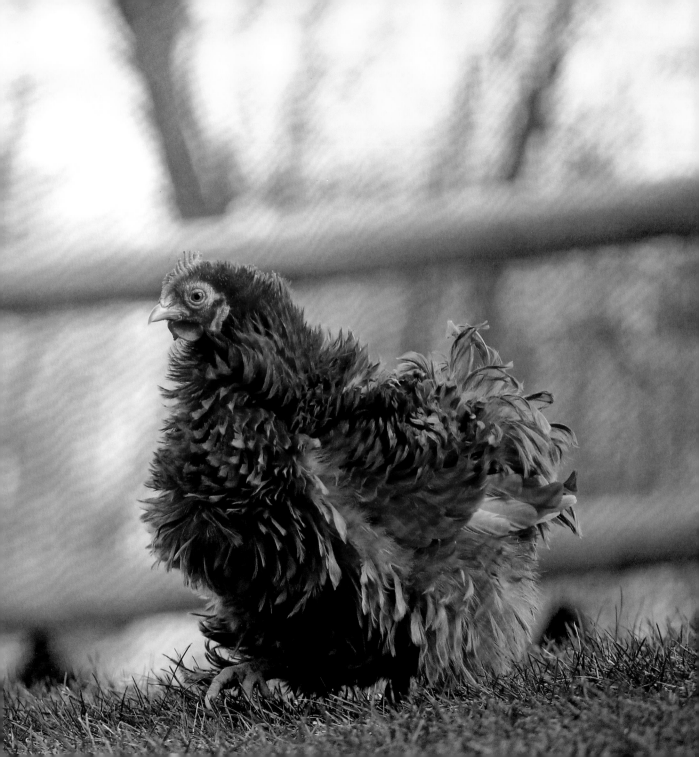

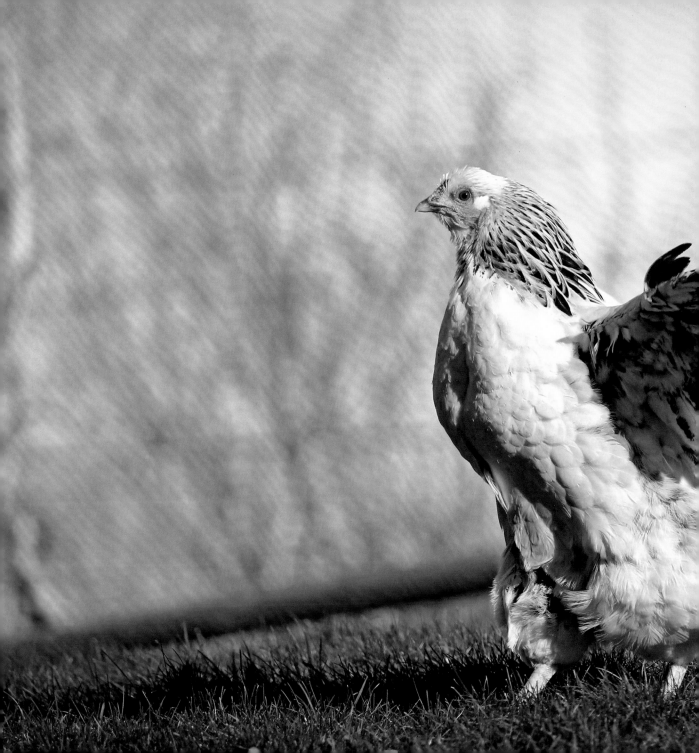

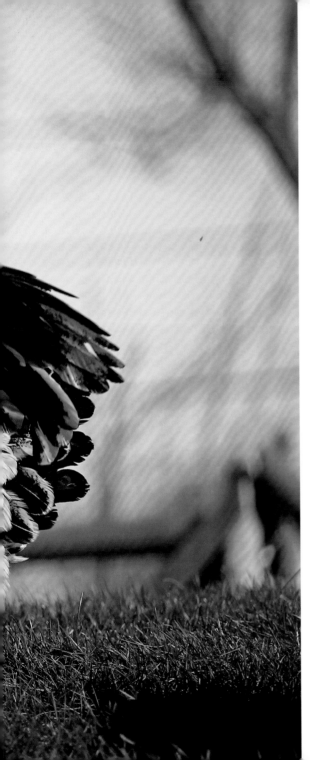

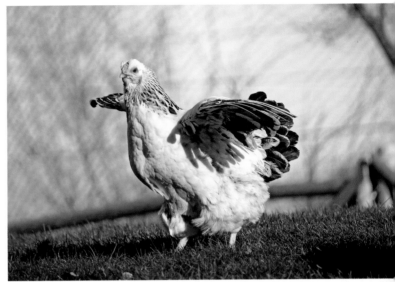

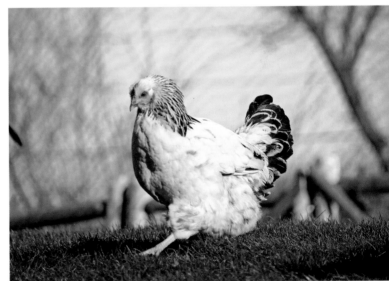

Lola has long aspired to be a Rockette. This may be her year.

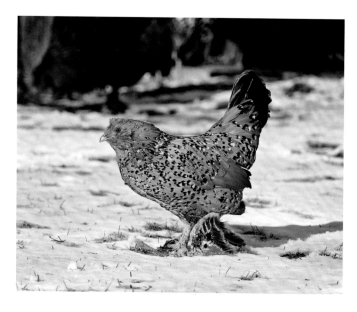

Due to weather conditions, traffic is down to two lanes in the chicken yard.

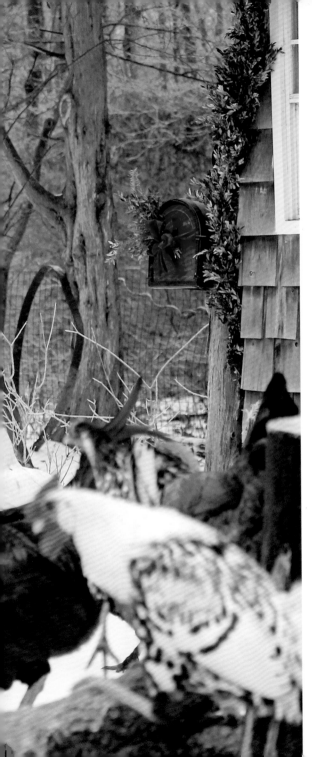

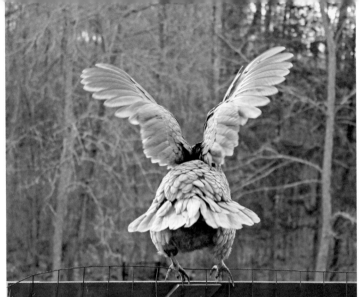

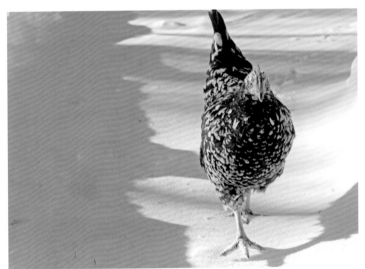

Having had enough of the snow, Shelly (opposite) decides to fly south for the rest of winter.

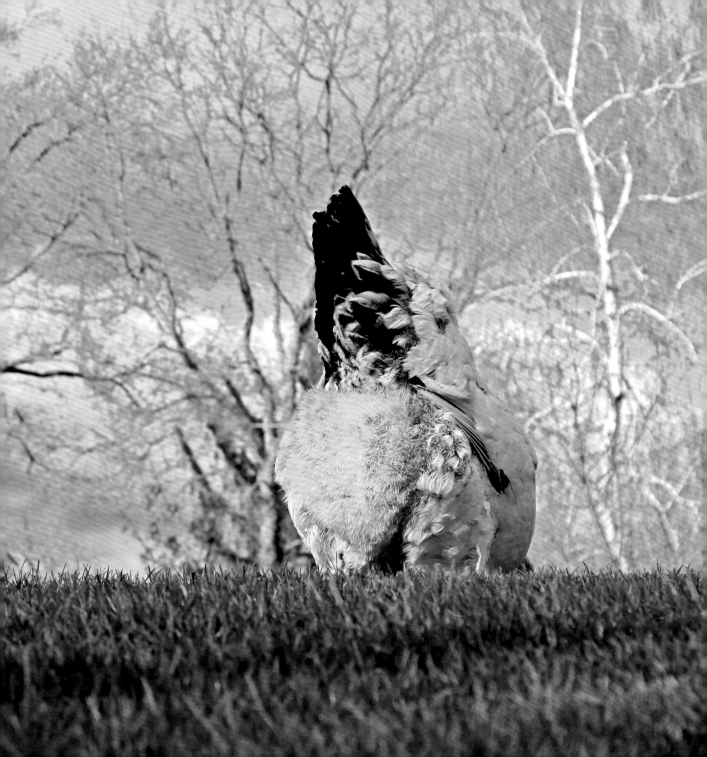

CHAPTER 7

Booty Beauty

From floofy, frizzled fannies to the rumpless, round Araucana caboose, my flock works the camera from every angle! One of my favorite views in the backyard is the south-facing end of a northbound chicken, so it's only fitting that the end of this book serves as a salute to booty beauty! #terrifictushies #junkinthetrunk #allbassnotreble

OPPOSITE: Lola, Columbia Wyandotte

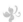

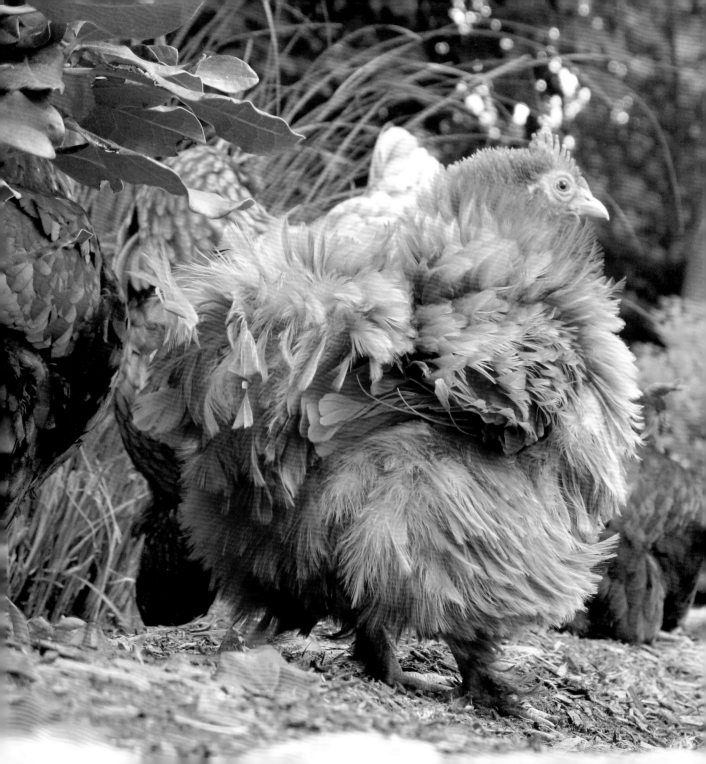

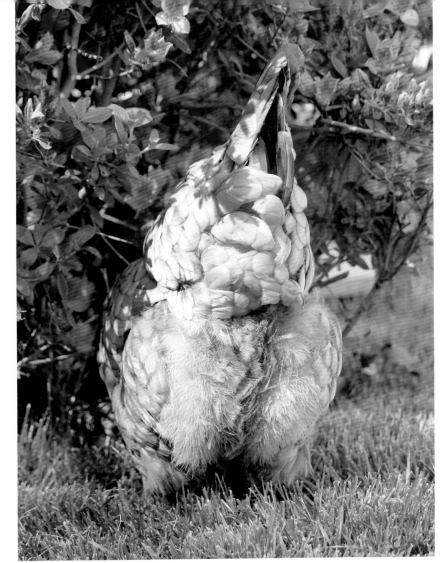

Bottoms up!

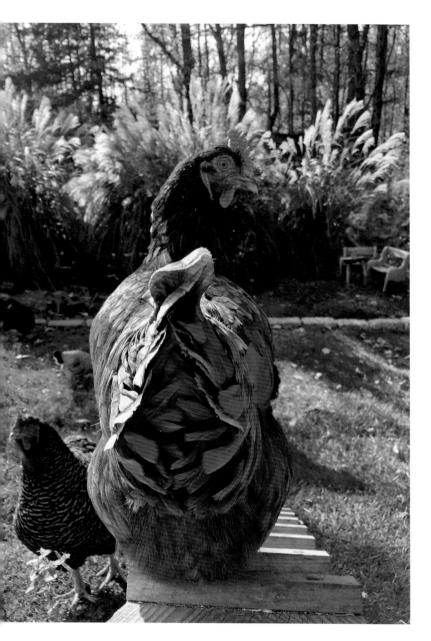

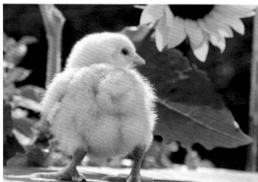

Scarlet: "Hey! The eyes are up here!"

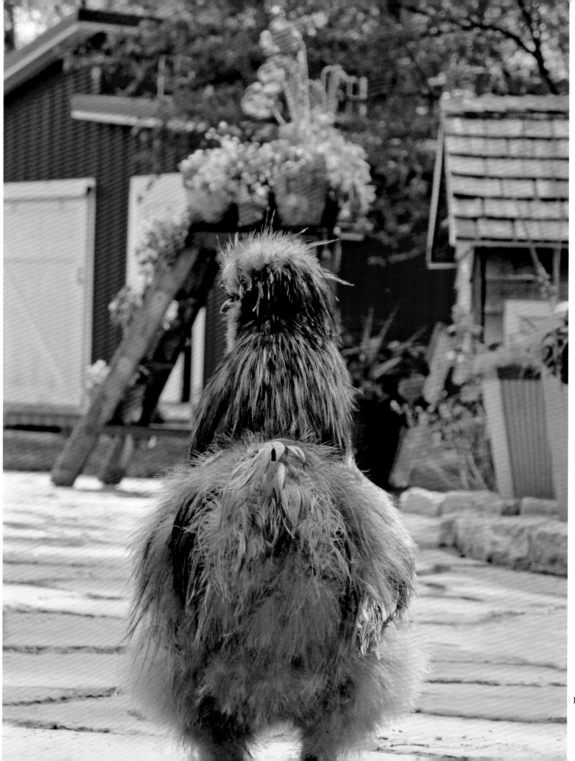

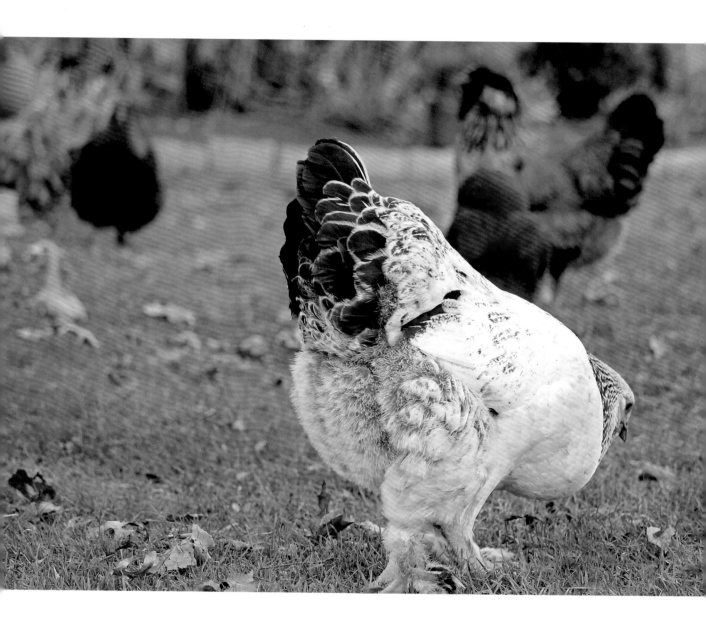

All the right curves in all the right places.

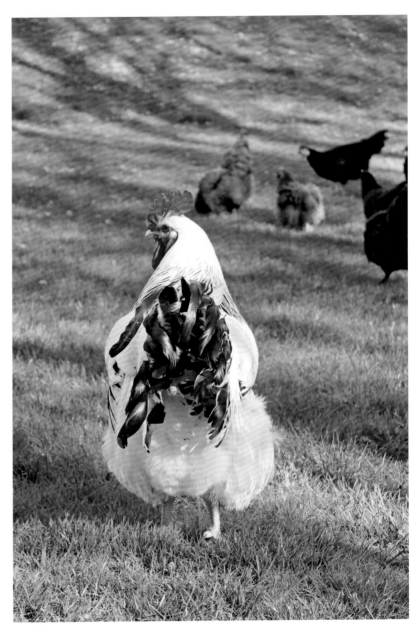

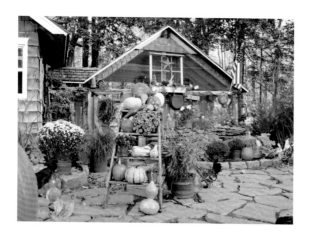

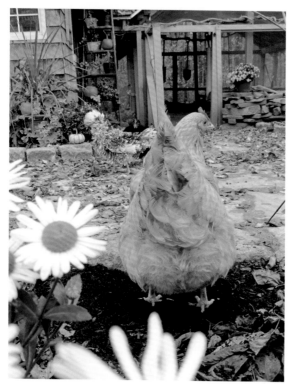

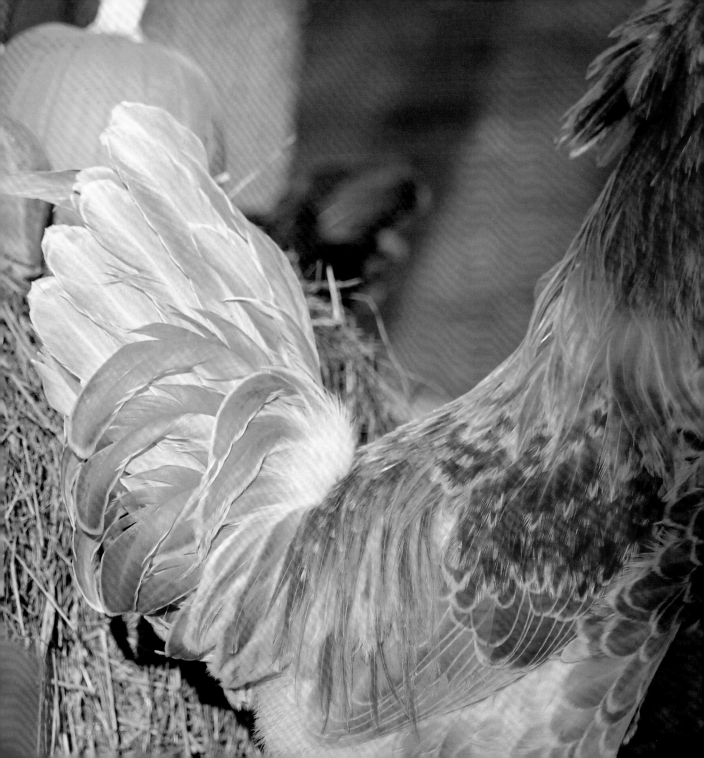

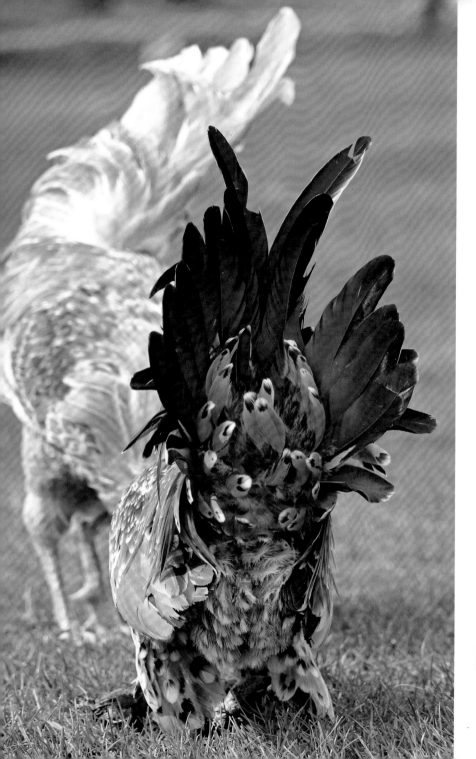
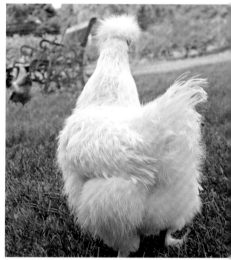
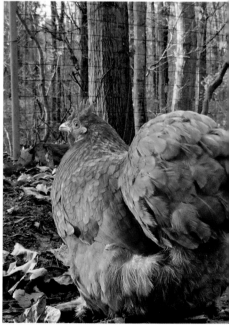

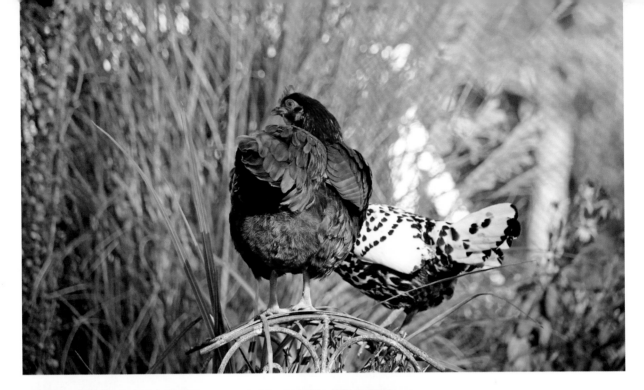

Awesome from any angle!

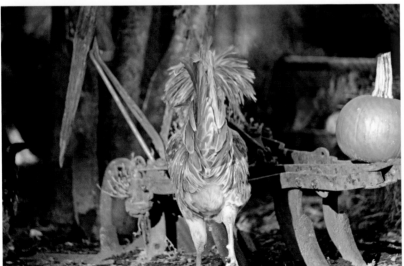

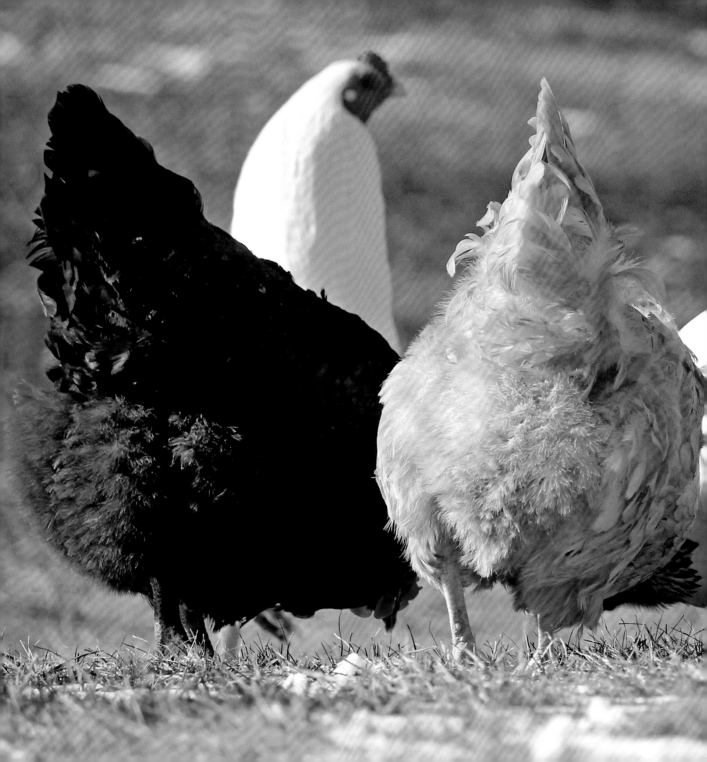

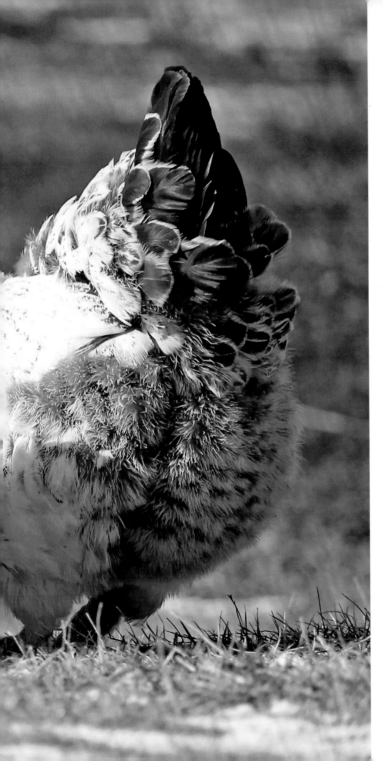

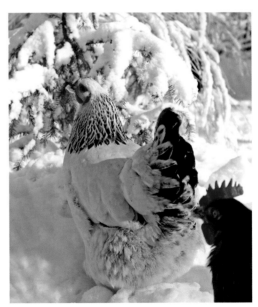

"I dropped a contact . . . no one move!"

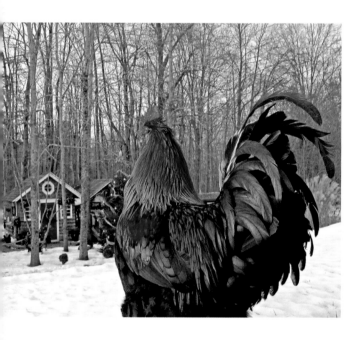

The End.

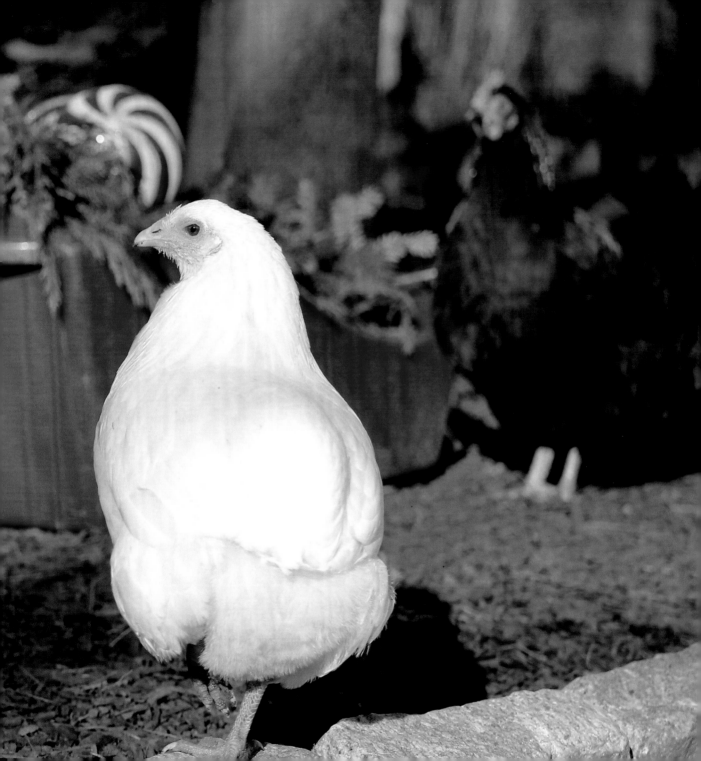

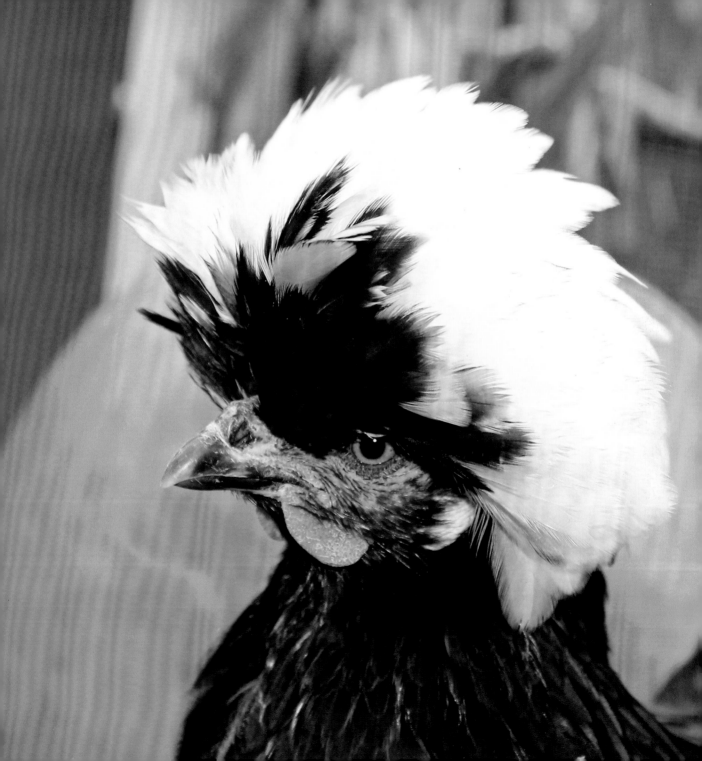

PHOTO INDEX

OPPOSITE: Polish, White Crested Black hen Doc Brown.

143

49, Spanish, Black White-Faced (top, Margarita); Wyandotte, Columbian (bottom, Lola)

50, Hamburg, Silver Spangled (Stella)

51, Easter Egger (Helen)

52, Plymouth Rock, Barred (Buelah)

53, Showgirl (half Silkie/half Naked Neck Turken hybrid, Fifi); Silkie, White (bottom, Freida)

54, Serama (Caesar)

56, Serama (Brutus)

57, Sussex, Light (top left, Chevy); Serama (bottom left, left, Caesar); Wyandotte, Columbian (bottom left, right, Lola)

58, Serama (top, Caesar); Marans, Black Copper (bottom, Blaze)

59, Marans, Black Copper (Blaze)

60, Wyandotte, Silver Laced (Sylvio)

61, Silkie (Ted E. Graham)

62, Serama (top, Caesar); Sussex, Light (bottom, Chevy)

63, Marans, Black Copper (Sparky)

64, Araucana, White (Alfalfa)

65, Sussex, Light (Chevy)

66, d'Uccle, Mille Fleur (Duke)

67, Hamburg, Silver Spangled (Sherman)

68, Polish, Buff Laced (Siegfried)

70, Sussex, Light (top left, Chevy); Serama (top right, Caesar); Marans, Black Copper (bottom left, Phoenix); Araucana, White (bottom right, Spanky)

71, Hamburg, Silver Spangled (Sherman)

73, Wyandotte, Silver Laced (Sylvio)

74, 75–79, Cochin, Red Bantam Frizzled (Rachel)

80, Serama (left, Caesar); Cochin, Red Bantam Frizzled (right, Rachel)

81–82, Cochin, Red Bantam Frizzled (Rachel); cat, Tuxedo (Serena)

83, Silkie, White (left, Freida); Cochin, Red Bantam Frizzled (right, Rachel)

84–85, Cochin, Red Bantam Frizzled (Rachel)

86–89, Marans, Black Copper (Blaze); Cochin, Red Bantam Frizzled (Rachel)

90–91, Cochin, Red Bantam Frizzled (Rachel)

91, Cochin, Red Bantam Frizzled (Rachel), Terrier, Yorkshire (bottom left, Milo)

92, Polish, Gold Laced (Roy)

94, Marans, Black Copper (a "Hen in Black")

95, Marans, Black Copper (Blaze at center); Red Sex Link and four Marans, Black Copper (the "Hens in Black"); Polish, White Crested Black (Doc Brown)

96, Polish, White Crested Black (top, Doc Brown); Hamburg, Silver Spangled (bottom left, Shelly); Wyandotte, Columbian (bottom right, Lola)

97, Showgirl (half Silkie/half Naked Neck Turken hybrid, Zsa Zsa)

98, Showgirl (half Silkie/half Naked Neck Turken hybrid, Gigi)

99, Polish (top left, Siegfried); Silkie (right, Ted E. Graham)

100, d'Uccle, Mille Fleur (Daisy)

101, Araucana, Black (Petey)

102, Marans, Black Copper x Wheaten (top left, ellen deHeneres); Dominique (top right, Niki); d'Uccle, Mille Fleur (bottom, Duke)

103, Polish, Buff Laced (Roy)

104, Cochin, Red Bantam Frizzled (Rachel)

105, Marans, Black Copper (top, the "Hens in Black"); Spanish, Black White-Faced (bottom, Margarita)

106, Seramas (Caesar and Portia)

108, Hamburg, Silver Spangled (Sherman)

109, Serama (top right and bottom, Brutus)

110, Serama (bottom left, Caesar); Polish, Buff Laced (bottom right, Roy)

111, Polish, Buff Laced (Roy)

112–113, d'Uccle, Mille Fleur (Duke)

114, Serama (Caesar)

115, Cochin, Red Bantam Frizzled (top, Rachel); Polish (bottom left, Roy); Serama (bottom right, Brutus)

116–117, Hamburg, Silver Spangled (Sherman)

119, Cochin, Red Bantam Frizzled (Rachel)

120–121, Wyandotte, Columbian (Lola)

122, d'Uccle, Mille Fleur (top, Daisy)

124, Hamburg, Silver Spangled (Shelly, flying) and various flock members

125, Olive Egger (top, half Black Copper Marans/half Blue Ameraucana, Iris); Sussex, Speckled (bottom, Kate)

126, Wyandotte, Columbian (Lola)

128, Cochin, Red Bantam Frizzled (Rachel)

129, Olive Egger (half Black Copper Marans/half Blue Ameraucana, Penny)

130, New Hampshire (left, Scarlet); Orpington, Buff (bottom right, chick)

131, Silkie (Ted E. Graham)

132, Brahma, Light (Libby)

133, Sussex, Light (bottom, Chevy)

134, Orpington, Buff (Houdini)

135, Polish, Buff Laced (Roy)

136, d'Uccle, Mille Fleur (left right, Duke); Silkie, White (top, Freida); Cochin, Red Bantam (bottom, Chandler)

137, New Hampshire (top left, Scarlet); Hamburg, Silver Spangled (top right, Shelly); Polish, Buff Laced (bottom, Roy)

138, Marans, Black Copper; Orpington, Buff; Brahma, Light

139, Cochin, Red Bantam Frizzled (top, Rachel); Wyandotte, Columbian (bottom, Lola)

140, Marans, Black Copper (bottom, Blaze)

141, Araucana, White (Darla)